the **digital photographer's** handbook

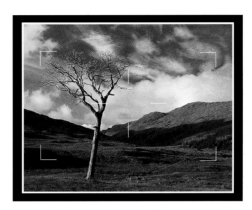

landscapes
and cityscapes

RotoVision

A RotoVision Book
Published and distributed by RotoVision SA

RotoVision SA, Sales, Editorial & Production Office
Sheridan House, 112/116a Western Road
Hove, East Sussex BN3 1DD, UK

Tel: +44 (0)1273 72 72 68
Fax: +44 (0)1273 72 72 69
Email: sales@rotovision.com
www.rotovision.com

10 9 8 7 6 5 4 3 2 1

ISBN 2-88046-655-5

Designed by Design Revolution

Printed and bound in Hong Kong by Printing Express
Production and Separations by Hong Kong Scanner Arts

the **digital photographer's** handbook

landscapes
and cityscapes

Simon Joinson

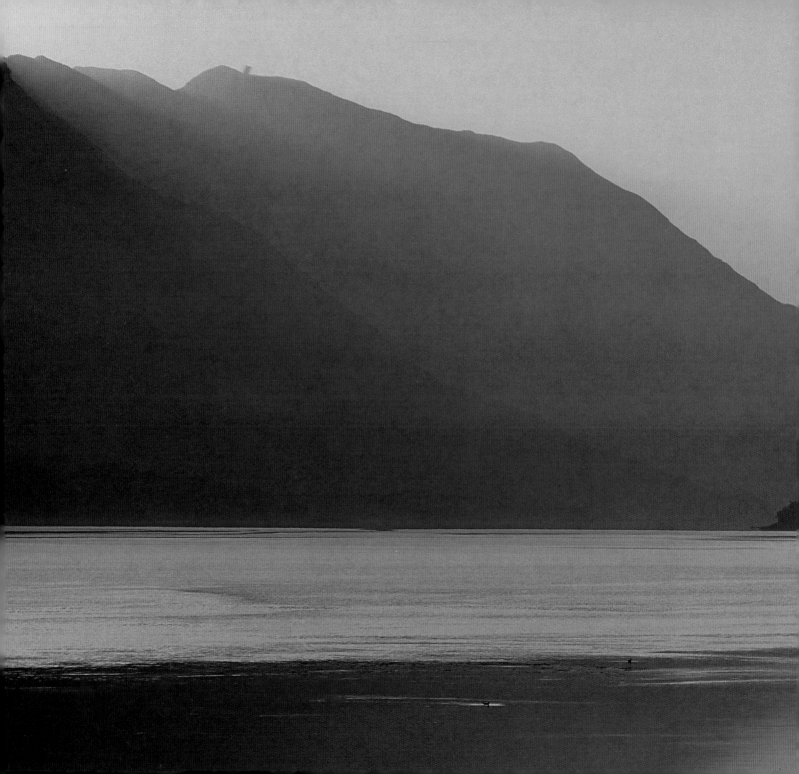

CONTENTS

Introduction

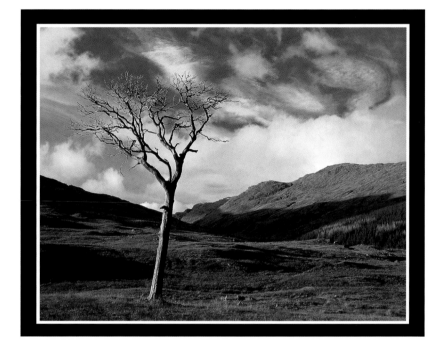

 Since the mid-nineteenth century photographers have been turning their lenses on the world that surrounds them. The vast majority of photographic enthusiasts are still motivated by the challenge of capturing the natural and man-made environment in all its variety.

This is not a book about photography as much as a book about making great pictures using the uniquely rich potential of digital photography. Most of what happens in these pages takes place 'after the fact', when the photograph has been taken and transferred to the computer. Although the old adage that you can't make a silk purse out of a sow's ear still holds true, it is possible – whisper it – to improve on nature, or at least to lend it a hand.

The major part of the book comprises a series of step by step projects designed to walk you through the most commonly performed correction, enhancement and manipulation tasks. The projects use Adobe Photoshop, but can all be followed using similar applications, such as Paintshop Pro, Photo-Paint and Picture Publisher, all of which offer very similar (if not identical) tools to Photoshop itself.

▲ **above: page 96**
Increasing color sat-
uration and contrast

▲ **above: page 98**
Converting to black
and white and
adding a border

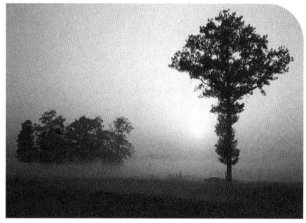

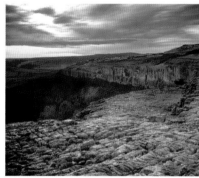

Digital disadvantages

Most serious landscape photographers are detail junkies; nothing is ever sharp or crisp enough. Part of the reason is that, especially when using a wideangle lens, there is simply lots of detail to capture. Leaves and twigs, blades of grass, tiny pebbles on a beach - all are part of the richly detailed natural world, and all can disappear into a blur if the resolving power of the camera is insufficient. The problem with a digital camera is not the lenses (which actually tend to be superb), but the CCD that actually captures the scene. The relatively

▲ above: page 78
Montage and collage

▲ above: page 106
Texture and color effects

▲ above: page 54
Dodge and burn

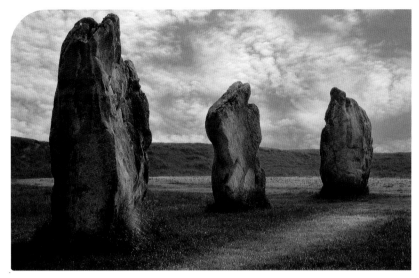

small number of pixels limits the size that landscapes can be printed without the lack of fine detail becoming an issue. It is only recently that serious landscape photographers have started to experiment with the latest, high resolution digital cameras – many of which can now rival 35mm film for prints of up to around 12x10 inches. The advent of the affordable high quality film and flatbed scanner has also helped open the door to digital imaging for those users who have no desire to abandon their film based equipment.

▲ **top**
Hue/Saturation, dodging and burning and unsharp masking

▲ **above**
manipulated in Photoshop

▲ **top/bottom: page 42**
Advanced color controls

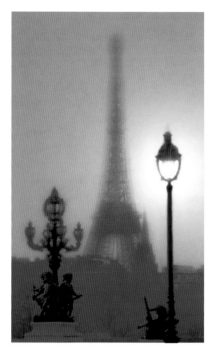

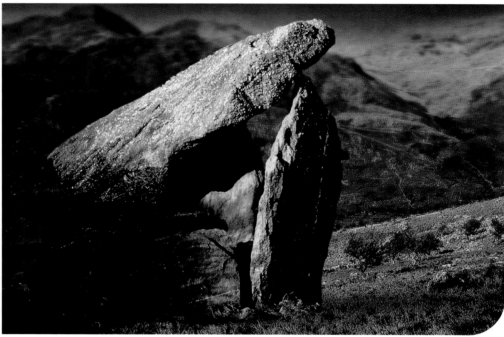

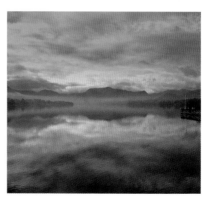

Digital Advantages

A digital camera offers some unique advantages of its own - instant feedback via the LCD screen, the ability to shoot freely without worrying about wasting film, fast and easy transfer of images to the PC and the ability to switch between color and black and white shooting at the flick of a switch. You can use the digicam like a visual scrapbook, capturing scenes of interest and revisiting them at a later date, or unusual details, skies and textures for use in montage or collage. This book is designed to help relative newcomers to digital imaging to use the amazing, powerful tools available within an application like Photoshop. There are plenty of tips on how to fix common problems, improve disappointing shots and transform your best shots into something special.

▲ **above**
blur, color variations and lens flare

▲ **above**
Megalith

▲ **above: page 62**
Graduated filter effect

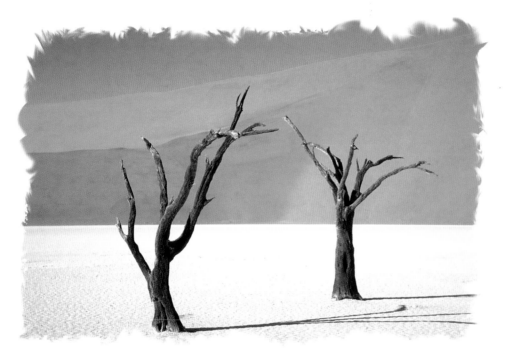

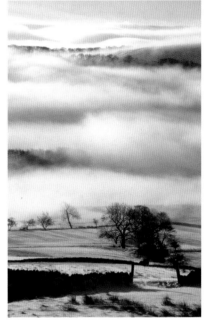

Tips for good landscapes

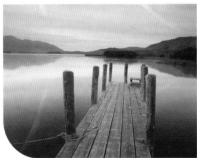

Good landscape photography takes a certain level of dedication and plenty of patience. First you must find your location. Often the most impressive scenery is in the most remote areas, although don't overlook the creative potential of well known places, especially if photographed at an unusual time of day or from an unusual viewpoint. Secondly you must choose the right time to shoot. All scenery changes dramatically as the sun moves across the sky: the best time for shooting is in the first hour or so after sunrise and the last hour before sunset; by far the worst is in the middle of the day, when the sun is highest in the sky. Don't restrict your photography to the summer months: some of the best light is in the autumn and winter, just as the long nights are drawing in.

Finally, carry a camera wherever you go. It's amazing how many glorious sunsets you see when all your gear is back home under the stairs - this is where a small digital camera is an absolute godsend.

▲ **top: page 86**
Creative border effects

▲ **above: page 36**
Using levels

▲ **above**
converted to greyscale in Photoshop

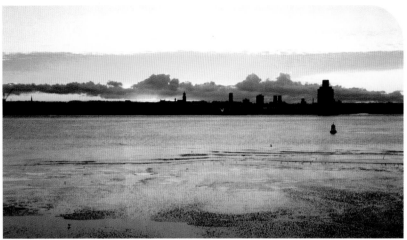

▲ above
manipulated in
PhotoImpact 6

▲ above: page 32
Basic corrections

▲ top: page 50
Creative cropping

▲ above: page 76
Adding mood

CHAPTER ONE

GETTING STARTED

The digital image

Shooting digitally or scanning existing photographs opens up a whole new world of creative possibilities. To really get the most out of the hardware and software available, it helps to understand the basic theory behind the production and manipulation of digital images.

 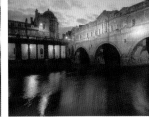

A digital image, no matter how it is generated, is made up of a grid of tiny squares called **pixels** (from picture elements). In the process of digitization, the scene (when using a digital camera) or photo (when using a scanner) is captured using this grid, with the color from the original assigned to each corresponding pixel. The more pixels used, the more detail is captured and the sharper the image appears. The number of pixels in an image is a measure of its resolution - the higher the pixel count, the higher the resolution of the image.

The resolution also defines how large an image can be printed at 'photographic quality', which roughly translated means without the pixels being visible in the print at normal viewing distance. Once you can see the pixels the image looks 'blocky'.

At the heart of the digital image lies the pixel. The more pixels in an image, the more detail captured and the 'sharper' the result appears. These four shots show the effect of increasing resolution (clockwise from top left):

50x39 (1950) pixels
240x190 (45,600) pixels
640x480 (307,000) pixels
2126x1668 (3.5 million) pixels.

How many pixels do I need? Resolution is one of the most important concepts in digital photography. It defines the quality of the image (in terms of the level of detail captured) and limits the size that you can print the results. The rough rule with resolution is that - within limits - you can't have too much. A truly photographic quality print at 16x20 inches needs at least 3200 by 4000 (12.8 million) pixels - more than any consumer level scanner or camera can produce. Most digital imaging is therefore something of a compromise. If you never print above 5x7 inches you needn't worry too much and even prints double that size are possible with affordable cameras or scanners.

The beauty of digital photography is the versatility of the software and the almost infinite possibilities on offer. Whereas the traditional darkroom requires skill and dedication, with the digital version you can start to create amazing images within minutes. With practice and experimentation it really is possible to transform the most mundane photograph into – if not a masterpiece – something worth printing.

The pictures on this page show the results of half an hour playing with the original digital camera shot (top right) in Photoshop, none of which achieved using advanced techniques or taking much time.

Shooting for digital manipulation When the digital photographer presses the shutter it is only the start of the creative process. Once the image is in the computer we can re-frame, remove unwanted elements, change colors and replace skies.

So it is important to think ahead when shooting and look for the creative possibilities in even the most uninspiring scene. Carry your digital camera at all times and photograph anything of interest – you've no film to waste.

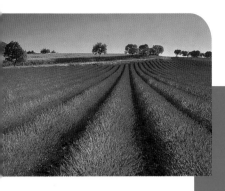

The digital process

The basic digital photography process consists of three distinct stages: input (or capture), processing and output. The processing stage is usually performed by computer, but some digital camera systems allow computerless printing or even emailing via a direct connection.

input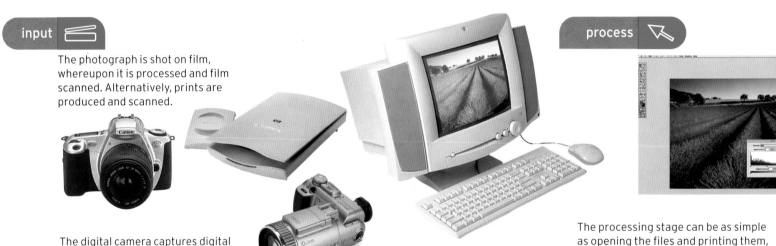

The photograph is shot on film, whereupon it is processed and film scanned. Alternatively, prints are produced and scanned.

The digital camera captures digital photos, bypassing the scanning stage. The images are transferred to the PC via a direct connection or a separate card reader.

process

The processing stage can be as simple as opening the files and printing them, or a highly involved series of corrections and manipulations.

Calibration Accurate color can be a real problem for digital systems and monitor calibration is a vital part of ensuring consistent color throughout the process. Photoshop itself has extensive color control and calibration features.

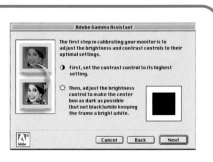

technical details
Pentax 6x7
55mm lens
Fuji Velvia film

Output in the broadest sense includes emailing photos or posting them on the web, or simply copying them onto a form of storage (such as CD-ROM) for archiving or distribution.

By far the most popular form of output is still the print. Most home users will produce their prints with a color inkjet printer, some of which can easily rival conventional 'wet' photographic processes for quality.

While there is a massive range of hardware and software on the market, there are only a few basic principles to understand.

Digital images are simply photographs in a form that the computer can understand - they can be described using numbers alone.

The digitization process splits the photograph into a grid of pixels, and the position and color of each of these pixels can be described numerically (a process known as 'bit-mapping'). The size of this bitmap - how many pixels it contains - determines the resolution of the image and how much detail it contains.

In a 24-bit color image (such as those created by digital cameras and scanners), the color of each pixel is defined as a mix of different proportions of red, green and blue (known in image editing as color channels). Each color channel can have one of 256 discrete values, from 0 to 255. The final image can thus have a maximum of 256x256x256 (16.7 million) different colors within it. Applications such as Photoshop allow you to alter the color values of each pixel individually or en masse. Thus if you use Photoshop's color balance tools to change the overall color of a photograph, you simply alter the red, green and blue values of every pixel in the image by the same amount.

The computer monitor also uses red, green and blue dots to create a visual representation of your digital image on-screen. Monitors work in exactly the same way as televisions, although they are higher resolution (the dots are smaller and more densely packed) as they need to be able to display readable text at small sizes.

The output stage of the digital imaging process (which actually includes displaying it on screen) usually takes the form of a print on paper. Color printers use cyan, magenta, yellow and black inks to recreate each pixel in the image (you cannot use red, green and blue inks; see page 28 for more on this). The process of converting what you see on screen to what you get in print is where color accuracy problems are most likely to occur.

Mac or PC? Although both Apple Macintosh and IBM PC (Windows) systems are perfectly capable of digital photography work, there are differences. Macs are generally considered easier to use and certainly offer much better system-level color management, but Windows PCs are cheaper, much more widely used and have a much wider range of general purpose software available. If you are totally new to computers and are only really interested in digital imaging, I would go for a Mac, everyone else will probably be better off with an IBM compatible Windows machine.

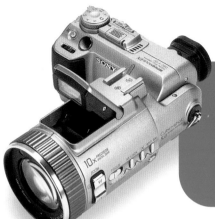

The digital camera

Unheard of a few years ago, the digital camera is fast replacing its film predecessor for both professional and amateur use. The latest models offer a huge range of photographic features, as well as extras such as movie clips or special image effects, and they often sport a decent lens too...

At the heart of every digital camera lies a sensor that converts light into an electrical signal. The most common type of sensor is the Charge Coupled Device (CCD). The CCD is made up of a grid of tiny photodiodes, each of which produces a signal whose strength depends on the amount of light falling on it. Each photodiode together with its lens and associated circuitry is known as a pixel – PICture ELement. When the digital camera takes a picture, the electrical signal from every pixel is recorded, processed and assigned a value between 0 (darkest) and 255 (brightest).

Since CCDs record only levels of brightness, they are actually color blind. To add color information from the scene captured, the sensor sits behind a mosaic of color filters, meaning each pixel records only red,

green or blue light. Sophisticated in-camera processing then reconstructs the full color scene. Each pixel is assigned a color based on a mixture of red, green and blue light. Using 256 different levels of each of the three color components allows for over 16 million shades, more than enough to look 'photorealistic'. This is also known as 24-bit color (the R,G, and B components each using 8 bits of computer data).

The number of pixels on the sensor (and thus in the resultant digital image) defines the resolution of the camera. The first generation of consumer digicams offered images containing about 300,000 pixels, whereas 3, 4 and even 5 million pixel cameras are now common. Digital camera resolutions are often quoted as the pixel dimensions of the final

image, rather than the total number of pixels therein. Thus a 1200x1600 pixel image comes from a 2 million pixel (or 2 megapixel) camera.

Virtually all digital cameras save the information captured in a compressed form (using a file format called JPEG) onto a removable storage card. JPEG compression has a small effect on the quality of the image, but does allow ten to twenty times more photos to be stored on each of the cards. The saved photographs are transferred to a computer for manipulation, printing or sharing via the internet.

Digital Video (DV) cameras now usually offer a stills facility, although it will not produce results as good as a dedicated unit

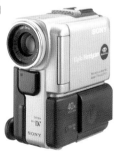

typical digital cameras

webcams
The least expensive digicams: 1 megapixel resolution, fixed lenses, no removable media.

entry level
Ideal for beginners on a budget. Resolutions and specification vary, but zooms of more than 1.5 megapixels are rare.

Although digital cameras come in a variety of shapes and sizes, most share common functions and features

Shutter release

Built-in zoom lens

Built-in flash. Some cameras allow attachment of external flash units

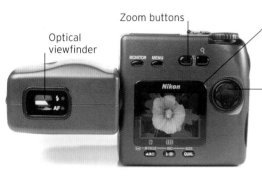

Zoom buttons

Optical viewfinder

Color LCD monitor. Usually around 1.8" – used for framing and playback

Controls for on-screen menus

Most cameras ship with a variety of transfer and image enhancement utilities

Camera features

Digital camera specification varies widely from very basic 'point and shoot' low resolution beginners' cameras and webcams, to highly sophisticated photographic tools with all the features and functions of a top level 35mm SLR.

All but the cheapest cameras have a small color LCD screen on the rear for previewing and reviewing shots (composition and playback) and a built-in flash. Most photographic enthusiasts will be looking at the mid to high end of the range and should aim for at least 2 million pixels, a 3x wideangle to short tele zoom and some exposure, focus and white balance overrides.

Image quality

For the photographic enthusiast, the quality of the final image is easily as important a factor as the design and specification. As well as resolution (which determines the amount of information captured), the performance of the camera's optics, exposure, focus and signal processing systems and the level of JPEG compression will all have an effect on the quality of the final image.

Most digicams attach to the PC via a USB connection

Storage and transfer

There are three commonly used solid-state (flash) storage formats: SmartMedia, CompactFlash and Memory Stick (unique to Sony).

A new format, the MultiMedia (or SD) card is also beginning to appear. There is not much to choose between the formats, although CompactFlash is used by the most camera models.

Cards are available in capacities from 2MB to around 256MB, the bigger the card, the more pictures you can take.

CompactFlash Type II compatibility allows the use of IBM's MicroDrive mini hard disks. These offer huge (1GB) capacities at affordable prices, but are much more fragile than their solid-state relatives.

Most cameras use a USB cable to connect to the host computer, although the use of a separate 'card reader' is an increasingly popular option.

mid-range
The most popular type of digicam. From 1.3 to 3 megapixels, usually with a zoom lens and some level of control.

high end
For the more serious photographer – higher resolutions (3 million pixels and over) and a full range of controls.

digital SLRs
The most expensive digicams: usually feature removable lenses and offer the ultimate quality.

Lenses

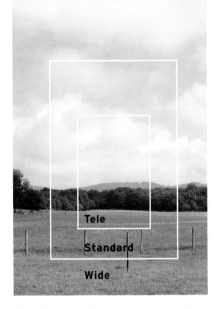

Tele

Standard

Wide

Landscape photography is most commonly associated with the wideangle lens. A wide lens allows you to capture lots of the scene in front of you and to include plenty of sky and foreground. Wideangle distortion can make objects nearer to the camera appear disproportionately large, whereas distant objects look even further away. Most zooms start at a focal length of around 35 or 38mm - not really wide enough for most landscapes. Look for a camera system that includes a wideangle converter.

Telephoto lenses can also be valuable tools for landscape photography. Ideal for picking out details and isolating subjects, the tele lens brings its own unique feeling to scenic photographs. By compressing perspective and concentrating on a narrow angle of view, a long lens can produce an almost abstract result, as shown in the shot above.

When shooting with a long lens - even the tele end of a 3x zoom - camera, shake can be a problem, so the use of a tripod is essential.

Most high end digital cameras sport some kind of zoom lens. The zoom allows you to change your angle of view by pressing the wide or tele buttons on the camera. The range of the zoom - from wideangle to tele - is usually quoted as either the 35mm lens equivalent (i.e. 34-102mm) or as a magnification range (i.e. 3x, where the telephoto is three times the focal length of the wideangle). Some camera systems allow the addition of extra wideangle or telephoto adaptors to extend the range.

Interchangeable Lens Digital SLRs If you feel restricted by the fixed zoom lens of a compact digital camera you may be tempted to invest in a digital SLR camera with removable lenses. There are several reasons why this might not be sensible. Firstly they are very expensive - most are many thousands of pounds for the body alone. Secondly, since the CCD inside the body is smaller than a 35mm frame, any lens used will see its effective focal length increased (by 50 to 100%), so true wide-angle photography is nigh on impossible. You would be better for the moment investing in a good 35mm scanner and sticking with film.

technical details
Mamiya RB 6x7 camera
50mm lens
Fuji Velvia film

technical details
Pentax 6x7
55mm lens
Fuji Velvia film

technical details
Canon EOS1n body Canon
100-400mm IS lens
Fuji Velvia film

keep in mind
Unless you have access to unlimited storage cards, the 'uncompressed' option is best left for one-in-a-lifetime shots. Most cameras have a 'High' JPEG setting, which allows 10x more pictures to fit onto each card with virtually negligible loss of detail.

Essential Accessories

Most compact digital cameras are not hugely expandable, but there are still plenty of add-ons and extras you'll need to consider.

Make sure you carry plenty of spare batteries. If your camera uses standard AA batteries, invest in a few sets of Nickel Metal Hydride (NiMH) cells. These rechargeable batteries offer by far the longest life and do not suffer from the memory problems associated with other types.

After power, the most common problem faced by digicam owners is running out of storage space. Although expensive, extra storage cards are essential. Don't buy the largest possible cards – you will be a lot less unhappy if you lose or damage a relatively cheap card. If you are out on a long trip it may be more cost-effective to buy a cheap laptop computer and transfer the images at the end of each day. Most laptops have a PCMCIA (PC card) slot and this can be used to copy images directly off the camera's cards using an inexpensive adaptor.

Other indispensable accessories include a sturdy tripod and a good, fully weatherproof case for the camera itself.

technical details
Canon EOS1n body
Canon 24-85mm lens
Fuji Velvia film

Quality Settings
The images captured by a digital camera are usually saved using a file format called JPEG. JPEG files use a system of compression that reduces the amount of disk space the picture takes up by 'throwing away' some of the picture detail. JPEG allows you to choose the level of compression; more compression equals lower quality but smaller files. This is the basis for the 'Quality' settings on a digital camera. The 'High' setting is only compressed slightly, and the effect on the image is usually insignificant. Most high end cameras offer an alternative to JPEG, usually to save the image as an uncompressed TIFF. Although this does improve the quality slightly, it does produce enormous files.

Uncompressed
This TIFF image took up 5MB on the camera card. Despite the high quality it is probably unsuitable for shooting in the field due to card space considerations. Using JPEG compression does not alter the resolution, it simply sacrifices some sharpness for the sake of file size.

Highly Compressed
This 'Basic' quality JPEG took up only 200KB (0.2MB) of space on the camera card, but the loss of quality is obvious.

By using a lower level of compression you can produce manageable file sizes with a negligible loss of quality.

23

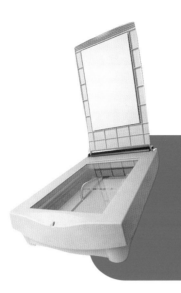

Scanners

Digital cameras may be fast and convenient, but many photographers' first taste of digital comes in the shape of a film or flatbed scanner. Affordable and easy to use, scanners also have the distinct advantage that you can still use your existing camera gear as well as working digitally with all the photos you've ever taken.

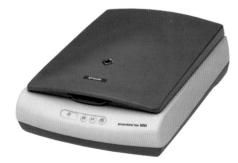

Scanners use exactly the same technology as digital cameras, except they move a narrow CCD sensor along a photograph, digitizing it one line at a time. This information is fed to the host computer where the scanner driver software processes it and constructs the digital image. Scanners attach to computers either via a USB or SCSI interface or, increasingly, via FireWire.

Flatbed scanners are used to digitize prints and other reflective originals of up to A4 size. The prints are placed face down on a glass plate and the lid closed before scanning. Some models are capable of scanning transparent media (films), usually via an optional transparency adaptor.

Resolutions are usually from around 600dpi up to 2400dpi and a wide range of models are available, ranging from the cheap to the really quite expensive.

Resolution

Scanner resolution is measured in dots per inch, since the absolute number of pixels will vary according to the physical size of the original. Thus a 600dpi scanner can produce a 600x600 (36,000) pixel image from a one inch square original, whilst the same scanner will produce a 4800x6000 (28.8 million) pixel image from an 8x10 inch original.

High precision 35mm film scanners are capable of resolutions of up to 4000 dpi. They can usually accept 35mm mounted slides and film strips and many offer an optional APS adaptor. With fewer models to choose from, starting prices are relatively high. Medium and large format film scanners are available, but are generally too expensive for non-professional use.

flatbed scanner resolution
Scanner resolution is sometimes quoted as a horizontal x vertical figure (i.e. 300x600 dpi). The first figure (horizontal) shows the density of pixels on the scanner CCD, whilst the second figure (vertical) is a measure of how far the CCD is moved between each 'line'. The horizontal figure is the truer measure of the 'optical' resolution of the scanner. Most manufacturers also offer much higher resolutions as an option, but since these are generated using interpolation the extra resolution is simply 'guesswork'.

Scanner Driver Software

The software supplied with the scanner is nearly as important as the hardware in ensuring good quality scans. The driver software usually comes as a 'plug-in' for Photoshop or similar applications and is accessed via the Import command (usually found under the file menu). Some scanners also ship with standalone software. Driver software varies widely, but the basic process is invariably the same: prescan, adjust scan settings and scan. The prescan allows you to define the area of the original you want to scan. As well as settings such as resolution and magnification, most drivers allow you to adjust the color, exposure and contrast of the image based on the preview image. The controls generally mirror those found in Photoshop, with the better software offering full levels, curves, color balance and sharpening functions. Most also offer a fully automatic 'idiot-proof' mode.

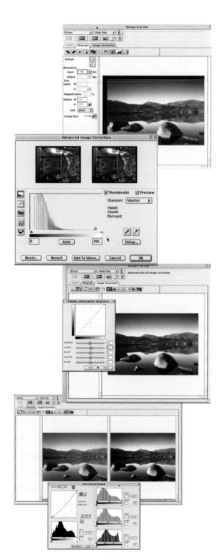

Scanning Tips

■ **Keep it flat:** The only way to get a sharp scan is to ensure the original is kept as flat as possible when scanning. This is especially true with flatbeds, where the weight of the lid alone may not be enough to hold things flat. For prints, try scanning with a large book on top of your original (leave the scanner lid open), and for films (using a transparency adaptor) a little scotch tape will hold curly originals in place.

■ **Keep it clean:** Keep both originals and scanning equipment spotlessly clean. A can of compressed air and a lens cleaning cloth should be all you need. Some film scanners now offer a hardware and software dust removal system – they actually work very well and are worth paying for.

■ **Don't go mad** with prescan color adjustments. It is very easy to mess up when working with the low resolution preview image and generally Photoshop's tools offer a finer level of control. Having said that, it is better to get the color, exposure and contrast more or less right at the time of scanning. Mastering driver software takes some time, so persevere.

■ **Resolution:** Try and scan at the correct resolution for your intended print size. Too high and you'll waste disk space and slow things down, too low and you'll get pixellated prints.

Software tools

The real power of digital imaging lies in the wealth of software tools available to subtly tweak or dramatically transform your photos in ways simply not offered by traditional methods.

There are broadly speaking three different types of image editing software, although many products blur the boundaries and a few defy classification.

The first, oldest group of products is that built on the Adobe Photoshop model (above): powerful, hands-on image editors with myriad correction, distortion and manipulation tools and a wide selection of effects filters. Virtually all the projects in this book were created using Photoshop. Photoshop is the undisputed king of the serious image editors but it is too expensive for many home users. Fortunately some alternatives come close to offering all the features of Photoshop in a more affordable package. Applications worth considering include Jasc Paint Shop Pro (left), Corel Photo Paint, Micrografx Picture Publisher and Adobe's own cut-down versions of Photoshop (Photoshop LE and the far superior Photoshop Elements).

A second group of photo editing software has emerged since the arrival of affordable digital cameras and scanners. These 'project led' programs are often very easy to use and tend to concentrate on making common tasks (color correction, printing and so on) easy, one-click tasks. The level of control and 'pixel by pixel' editing is often limited, but as a user-friendly and affordable entry point, applications such as MGI PhotoSuite and Adobe PhotoDeluxe are worth consideration. Ultimately, however, there is a limit on the creative

Photoshop versions
There are currently three variants of Photoshop on sale; Full Photoshop (currently on version 6.0.1), Photoshop LE (often given away free with scanners and digital cameras) and the relatively new Photoshop Elements. Full versions of Photoshop (any version from 5.0 onwards) offer the most powerful tools, whilst LE is crippled somewhat by its massively reduced feature set. Elements offers much of the power of Photoshop 6.0 in an easier to use, friendlier package.

input you can have on the process, and you can soon tire of making calendars and birthday cards from your snaps. Most users will outgrow these applications and, as their interest in the creative side of digital imaging develops, they will inevitably move on to a more serious program.

The third type of software covers a wide range of products that perform one or more specific tasks. This includes 'funware' such as Kai's Super Goo (right), panorama creation software and template-based print programs (for creating cards, certificates and calendars).

A separate group of 'mini applications' that run inside programs such as Photoshop (known as plug-ins) are available. These range from the useful to the frankly bizarre.

Albums & Slideshows

Albums & image databases

Keeping track of hundreds of digital images can be difficult. Applications such as Canto Cumulus and Extensis Portfolio offer powerful ways to catalogue and classify your ever growing image library. As well as basic views of thumbnails, multiple text labels can be attached to each image to allow for complex searches. At the other end of the scale, inexpensive 'image browsers' allow you to view the contents of a folder of images as thumbnails.

Slideshows

Sharing your images with other computer users is as simple as sending them a disk or even emailing a selection of photos. It is also possible to create self-running 'slideshows' with sophisticated fades and dissolves between frames and – should you wish – text captions. Some image editing applications (such as MGI PhotoSuite) offer this feature, or there are several standalone slideshow applications, the best of which is probably ScanSoft Kai's Photo Show.

Color printing

The complexities of the printing process could easily fill a book on their own, but a basic understanding of how the systems work is important for getting the most out of your digital images in print.

Digital cameras, scanners and monitors use a combination of red, green and blue light to create all the colors in the spectrum (RGB color). This is called an 'additive process' as the more color you add the closer you get to white. A wide range of colors can be generated in this way, although some very dark tones can be difficult – a computer monitor, for example, will rarely display anything approaching a true black.

Printers use a combination of cyan, magenta and yellow pigments in a 'subtractive' process (adding pigments 'subtracts' from white, resulting in a darker color). In theory, 100% each of the three pigments should result in black, but as this is rarely the case a fourth ink (black) is added to produce the very darkest tones. This CMYK (K for black) process is the basis for all printing, from books to newspapers to home inkjets.

The four inks are laid down in patterns of tiny dots using a 'dither pattern'. This process lets some of the paper show through, allowing pale tones to be recreated (the inks themselves can only be laid down at 100%). At normal viewing distance the dots themselves are invisible to the naked eye, and the eye 'mixes' them to give the impression of a continuous range of tones.

Photo quality inkjet printers add two extra inks (pale cyan and pale magenta) to reduce the visible graininess in pale pastel tones caused by the wide spaces between the dots.

alternatives to inkjet printers
Although inkjet printers are by far the most commonly used output devices, they are not the only technology available. Small 'postcard' printers using dye-sublimation or thermo-autochrome offer high gloss, high quality 'fade proof' prints, albeit at a higher cost. You can now also take a disk or memory card full of images to a high street photo developers to have your digital photographs printed onto conventional photographic paper.

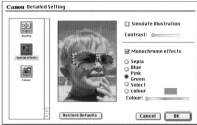

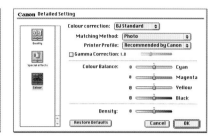

Virtually all home printing is done using a color inkjet device. These have developed rapidly over the last few years and the best can offer quality that rivals conventional photographic prints. The best choice for photographers is a 'photo quality' printer that combines high resolution with six color printing and advanced driver software.

Other printer technologies, including Dye Sublimation and Thermo Autochrome, are used in small postcard printers and offer excellent quality as well as direct print capabilities with some digital cameras.

The driver software provided with a printer is as important to the quality of the resultant print as the hardware itself. Most photo quality printers offer a wide range of control over print parameters, including color management and occasionally even special effects.

Using the best possible paper is essential to getting good results from an inkjet printer - there are plenty to choose from so it is worth experimenting until you find one or two you really like.

Some of the hundreds of different inkjet photo papers on the market. As well as the usual gloss and matt, there are a variety of special surfaces available, including cloth, watercolor paper and stipple.

Printing Tips

■ Print your images at between 200 and 300 dots per inch (dpi) for the best possible quality on an inkjet printer. In Photoshop use the Image Size command to change the resolution (making sure Resample Image option is off) as shown on the right.

■ Avoid using the color correction controls in the printer driver software - if your print's color doesn't match what you see on-screen, then the screen needs calibrating.

■ Most inkjet prints fade in direct sunlight, so keep copies of your digital images safely, that way you can reprint at a later date.

■ Always use high quality inkjet photo paper - anything else will reduce the quality of your output.

By altering the physical output size but not the number of pixels in the file you increase the print resolution to 200 dots per inch - perfect for 'photographic' quality output.

The resolution of an image refers to the number of pixels, but print resolution is measured as a pixel density (dots per inch). This file is 1585x1095 pixels, but the output resolution is set to 72 dots per inch, making an enormous (55.92x38.63cm) print.

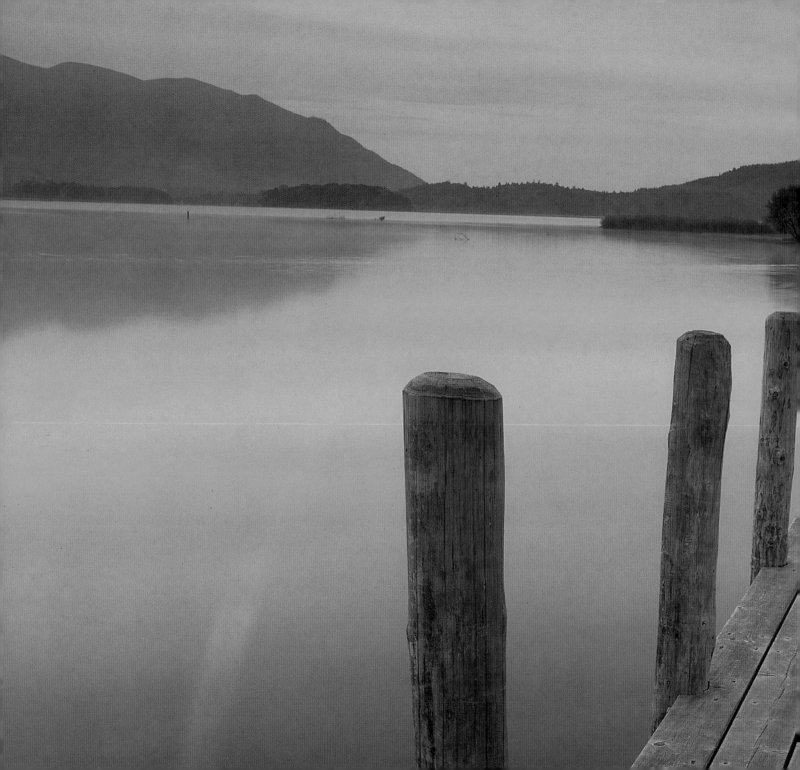

CHAPTER TWO

SIMPLE STEP BY STEP PROJECTS

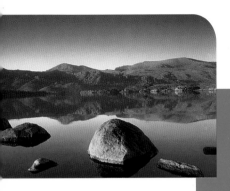

Basic corrections

It is rare – no matter how hard you try – that the image that comes out of your scanner or digital camera needs no work. Before we get stuck into the more advanced corrections and manipulations, let's get down to basics with a quick guide to a few simple processes needed to get the best out of all your photos.

scan it

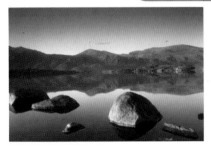

01 The basic principles on the following four pages apply equally to scans or digital camera shots with the exception of the dust and scratch removal, which is only necessary when scanning your prints or slides. We'll start with a raw scan straight out of a typical 35mm film scanner.

02 After cropping (if necessary), the first job is to correct the exposure and contrast. We'll look at manual corrections from page 38, but for now we'll see what our image editing application can do. If the color looks right, but the exposure or brightness look wrong, choose Image>Adjust> Auto Contrast; if there is also a color cast try Image>Adjust>Auto levels .

manipulate it

03 Dirt is a common problem with film scanners, but can easily occur with flatbeds too. Take a look at this enlarged section from our original scan. The whole frame is covered in dust spots and scratches. Many applications offer automatic dust and scratch removal, but this will also remove fine details from the image. The tool we're going to use to 'rub out' the spots and scratches is the Rubber Stamp (a.k.a the Clone tool).

	tools	navigator	
technical details	Change Color mode	Levels controls	p36
Olympus OM4 TI	Curves	Curves controls	p45
28mm lens	Grain Filter	Greyscale mode	p98
Fuji Velvia film	Add Noise	Hue/Saturation	p45
	Hue/Saturation		

05 There is a definite knack to using the Clone tool to remove dirty marks from your scans. The tool works in a very simple way: to define the source point (that's the pixels you are cloning from), alt-click. To paint with the source pixels simply click and move the mouse like any other paint tool (without holding down the alt key). In the example above left, I alt-clicked in the position circled in white, then clicked where the yellow circle is and painted in the direction of the arrow, following the shape of the scratch, ending up roughly in the position shown in the right-hand screenshot.

04 Like most editing tools the Rubber Stamp acts in the same way as the paintbrush; you can change the shape and size of the brush itself by selecting any one of the presets in the Brushes Palette. You can also change the opacity of the brush from 1-100% (via the tool options palette, double click on the Rubber Stamp icon in the toolbar); for this purpose leave it set to 100%, full strength.

Cloning Tips

- Use a soft-edged brush for a more seamless clone.
- Do not place your source and target points too close, especially with a large brush size – you will end up with a 'zebra stripe' effect by repeatedly cloning the same small group of pixels.
- Make sure the area you clone from has a tone and texture that matches the target area or you will make matters worse.

In the example above we need to remove the two dust spots circled here.

If we use a sample point in a darker area the result is, unsurprisingly, a dark blob.

Choose a point to clone from that is in an area of similar tone for a seamless result.

06 The final step in the cleanup process is to sharpen the image. Most scanners and virtually all digital cameras produce images that benefit from a little software sharpening. Although most applications offer a simple 'Sharpen' command, it pays to get into the habit of using 'Unsharp Masking'. Unsharp Masking (USM) allows you a high degree of control over how the image is sharpened with visual feedback in the form of a preview screen.

What is unsharp masking? Despite the rather confusing name, USM is a process that makes pictures look sharper. It does this by locating pixels that differ from surrounding pixels by a user-defined amount (the 'Threshold') and increasing their contrast by the 'Amount' you specify. The 'Radius' figure specifies how many surrounding pixels each pixel is compared with.

The net result of all that is to increase the contrast of edges, enhancing the appearance of sharpness.

 manipulate it

01 The figures you enter into the USM dialog will depend on three things: the resolution of the image, the quality of the picture (sharpness, noise, JPEG artefacts etcetera) and what you intend to use it for. Experiment with the settings to get a feel for what effect they have on the image. The Amount figure simply changes the strength of the sharpening. You will rarely want to go above about 120%.

02 The Threshold figure defines how different two areas need to be before being considered by the USM filter to constitute an 'edge'. The effect is to protect areas of continuous color from the sharpening. The Radius defines how far from each pixel the USM filter looks for an edge. Increasing this figure beyond about 50 will result in very contrasty images, and it is usually left under 10 unless you are after a special effect.

03 People generally find that their particular scanner or digital camera virtually always needs the same degree of sharpening, and therefore have at least a starting point. The figures shown in the box above - Amount 100%, Radius 2 pixels and Threshold 1 - are the settings I use for my 35mm scanner. My digital SLR (which has its own sharpening turned off) needs the Amount increasing to 200%.

keyboard shortcuts

Zoom in	control-plus(+)/⌘-plus(+)
Zoom out	control-minus(-)/⌘-minus(-)
Rubber stamp	S
Hand tool (to move around image)	spacebar
Auto Levels	control-shift-L/⌘-shift-L
Auto Contrast	control-alt-shift-L/⌘-alt-shift-L

keep in mind
The effects of Unsharp Masking are much more pronounced on-screen than in high resolution prints. Experiment with different settings to find what best suits your input and output devices.

These basic steps - scan (or shoot digitally), crop, correct exposure, remove imperfections (from scans), sharpen and save - represent the 'bare essentials' of the digital process. Although some images will not need every step, it is a rare photograph that would not benefit from at least two of the stages. The difference even a couple of minutes work can make to the final print is remarkable.

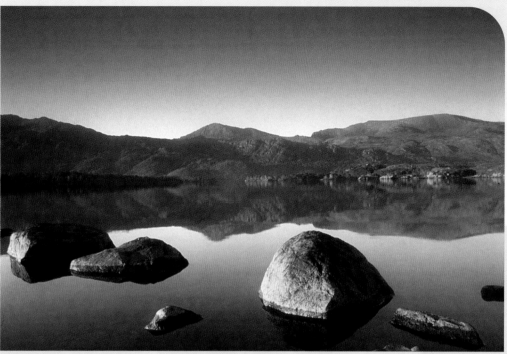

 Before After ▶

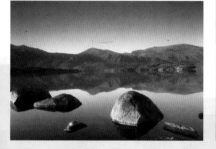

Correcting Digital Camera Images

- Digital camera images are often flat and dull looking, but lurking inside the most unpromising shot there is often a much more colorful, vivid photo.
- Use Levels or Auto Levels to correct the brightness and contrast and you'll see a massive improvement.
- Take care when using Unsharp Masking on JPEG images: too much and you'll exaggerate the artefacts and fringes created in the compression process. This is the strongest argument for

using the best quality setting on your digicam, or even opting for the uncompressed option, if available.

- Photoshop allows you to create and save a series of corrections that can be run on a single image or a whole batch of files. These 'Actions' are useful if your camera consistently produces results that need the same corrections.
- Digital camera files are inevitably created at 72dpi (screen resolution). Remember to resize to a higher resolution before printing (see page 29).

▲ Before

▲ After

Using levels

At the heart of color and contrast control lies the histogram, a graphic representation of the spread of brightness levels in the image. Master the interpretation of histograms and the use of the levels dialog, and you will have at your fingertips a wealth of subtle and powerful controls.

 scan it

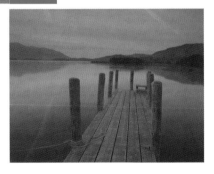

This original scan, which has had no processing applied to it at the scanning stage, closely matches the original 5x4" transparency color-wise, but lacks contrast and looks grey due to underexposure. This flat tone is also typical of digital camera pictures as they come off the card.

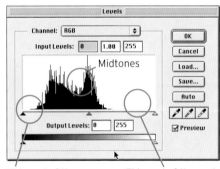

This end of the scale shows the darker (shadow) tones

This end of the scale shows the lighter (highlight) tones

Interpreting levels This is the Levels dialog for the image as opened in Photoshop. The graph area is known as a histogram and shows the number of pixels at different brightness levels in the image.

The grey gradient at the bottom of the dialog shows the entire range of tones possible, from black (0) to white (255). Ideally we want to use as many of these tones as we can.

In this example, the distribution of tones falls short at both the shadow and highlight ends of the scale, which explains the rather flat look of the photograph.

We can use the Levels dialog to remap each pixel's brightness so the darkest point corresponds to black (0) and the lightest to white (255).

TIP BOX

When using Levels, turn off the preview (using the checkbox) and hold down the alt key whilst moving the white (or black) sliders to work in 'threshold mode', allowing you to see where the brightest (or darkest) points in the image are.

technical details
Pentax 6x7
55mm lens
Fuji Velvia film

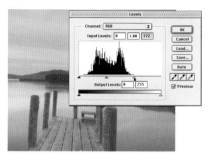

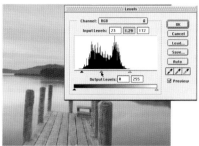

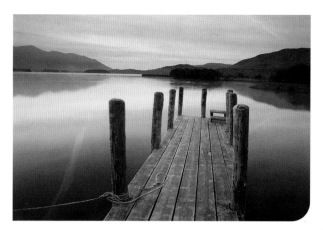

manipulate it

01 First the highlights. Drag the white slider until it is at the point where the histogram starts to have non zero values. You will see the image brighten as you do this (if not, click on the preview checkbox).

03 The middle (grey) slider allows you to alter the level of the midtones in the image without dramatically affecting the highlights or shadows. This alters the overall contrast of the image. Experiment by moving the slider to the right and left to lighten and darken the midtones respectively.

04 Using the Levels sliders in this way is a quick, easy and usually pretty reliable way of correcting the brightness and contrast of images where there is no need to alter the overall color balance. As it relies to a certain extent on a visual assessment of the changes made, it is important that your screen is as well calibrated as possible.

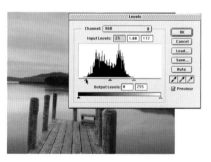

02 Now for the shadows. This time drag the black slider until it is under the part of the histogram where the darkest pixels are (where the graph first starts to lift above zero). You have now successfully mapped the darkest pixels in the image to black (0) and the brightest to white (255).

navigator
Turn to page 40 to find out how to use the Levels controls to alter the color balance of an image with a color cast.

Auto corrections Most editing applications offer some kind of auto exposure fix. In Photoshop there are two such features: Auto Contrast (Image>Adjust>Auto Contrast) and Auto Levels (Image>Adjust>Auto Levels). Auto Contrast sets the highlight and shadow points automatically (i.e. it performs steps 2, 3 and 4 for you), whilst Auto Levels also attempts to correct the color balance. Auto Contrast (top image) works pretty well, and for 'standard' scenes with an even mix of colors, Auto Levels (lower image) can also be very effective. However, most 'power users' rarely, if ever, use either feature, as both Auto Contrast and Auto Levels can clip extreme highlights and shadows, and Auto Levels can make quite dramatic, unwanted changes to the overall color balance.

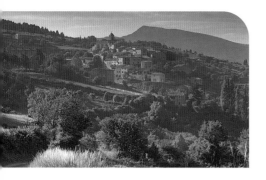

The techniques described on the last two pages are fine if it is only the contrast of your image that needs tweaking, but what if the color is also wrong? The Levels controls also offer tools to counteract color problems caused by wrongly calibrated scanners, poor white balance or wrong film type.

scan it

Our original scan, which has had no processing applied to it at the scanning stage, pretty closely matches the original 35mm transparency (top). The shot lacks contrast and has a distinctly blue color cast as a result of a mismatch between the color temperature of the scene and the film used.

01 The white and black sliders under the Levels histogram define the white (highlight) and black (shadow) points in the image. We can also tell the application where these points are directly using the white, grey and black point eyedroppers. The difference here is that not only are you remapping pixels' brightness, but their color too. First select the white point eyedropper. Click on the very lightest point in the image that contains detail. As soon as you click in the highlight you will see the entire image change.

02 Now use the black point eyedropper to click on the darkest point in the image. You may need to click a few times to get it right. At this point you may need to use the grey slider (as described on the previous spread) to lighten or darken the midtones. In this case the slider needed to be moved quite a way to the left (to lighten the midtones).

TIP BOX

When using the white eyedropper, do not click on specular highlights (white reflections on metal, glints in water and so on), as they do not contain detail and they will give a false white point.

technical details	keyboard shortcuts		tools
Pentax 6x7	Adjust Levels	Control-L/⌘–L	Levels
55mm lens	Auto Levels	Control-Shift-L/⌘-Shift-L	Rubber stamp
Fuji Velvia film	Auto Contrast	Control-Shift-Alt-L/ ⌘-Shift-Alt-L	Paste into

03

The last step is to define the grey point. This is vital if your photograph - as in this case - still has a distinct unwanted color cast. Select the grey point eyedropper (the middle one of the three) and click on a point in the image that should be a neutral grey. In this case I used part of the driveway (circled in red).

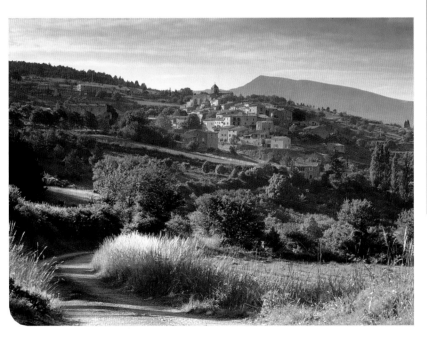

Eyedropper options The eyedroppers in the Levels dialog share settings with the main eyedropper tool in Photoshop's toolbar. It is set by default to 'Point Sample' mode; it measures a single pixel at a time. It is worth changing this to something a little less picky. Double click on the eyedropper tool to bring up its options and change the Sample Size to '3 by 3 average'.

Note also that double-clicking on the eyedroppers in the Levels palette allows you to change the RGB values of the white and black points. For inkjet printing this is not really necessary.

You can mix and match the various techniques; for example, use the sliders to set the black and white points and the grey point eyedropper to correct the color. As with all tonal corrections there is a certain amount of visual assessment, and this means two things: (i) the more experience you have the better, and, (ii) your monitor must be calibrated to display colors as accurately as possible.

keep in mind
You can keep re-sampling with the eyedroppers until you find the right place to define as a white, black or grey point.

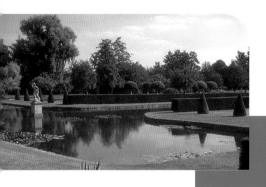

Color balance

The digital darkroom always offers more than one route to the same destination - the one you choose will be decided more by personal preference than anything else. Previously we looked at corrections using the Levels controls, now we'll look at a couple of tools designed purely to alter color balance.

scan it

01 This scan of a 35mm slide has a couple of problems, despite being scanned using 'automatic' exposure and color balance. As well as being a little underexposed it has a distinct greenish cast.

manipulate it

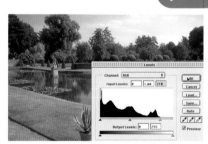

02 First job is to lift the exposure a little, for which there is no substitute for the Levels controls. Here all that is necessary is to drag the white point slider over to the left until it is under the lightest pixels in the photograph.

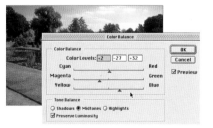

03 The most 'hands on' approach to correcting color casts is the Color Balance control (Image> Adjust> Color balance). Using the preview to judge the correction needed, I simply moved the sliders to reduce the amount of green and to slightly up the blue in the midtones.

technical details
6x4.5cm
single lens reflex
45mm lens
fujichrome velvia

tools
Variations
Color Balance
Levels

keep in mind
Remember that assessing color balance visually is somewhat subjective. Your monitor's settings, the color of the light in the room and even the surrounding walls can all affect how you perceive on-screen color.

04 If you know there is something wrong, but can't quite work out what, try using the Variations feature (Image>Adjust>Variations). Here you are shown six variations of color in a ring around the current settings. Click on the thumbnail that looks best and you'll be presented with another six variations. Along the right of the box are three variations of brightness, which – if you did your work at step 2 right – you won't need.

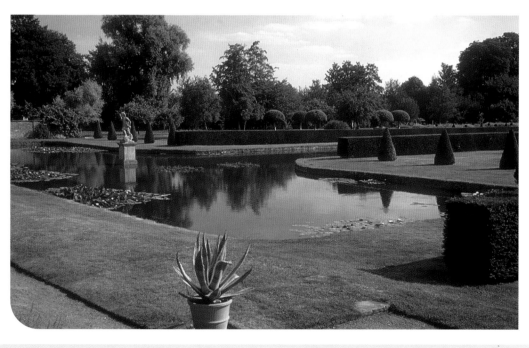

05 The Variations window can make correcting color very simple, but it is a rather unsubtle approach. It also has the disadvantage that you will never learn how to use the finer controls if you use it all the time. If you feel comfortable using it, however, stick with it.

As both the techniques described on these pages rely totally on the visual assessment of the changes you make, it is more important than ever that you have calibrated your monitor correctly. You may also find that your printer refuses to produce output that matches what you see on screen. In this case, the Variations feature can be very useful for quickly producing a set of test prints in order to discover exactly what color shift the printer is producing.

keyboard shortcuts

Adjust Levels Control-L/⌘-L
Color Balance Control-B/⌘-B

Playing with color

Now we've covered the basics of color correction – how to get the color in your landscapes right – it's time to look at some more advanced techniques. We'll also explore how the tools we've used so far can be used to make much more dramatic color changes purely for visual effect.

 scan it manipulate it

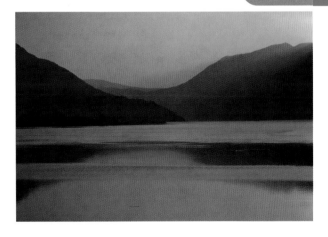

01 We'll start with this scan of a beautiful lake shot just as the sun goes down and scanned with automatic exposure enabled. The resultant image is a touch on the flat side and the dusk colors look more muted than I'd ideally want.

02 Perhaps the most unsubtle of all color corrections, the Brightness and Contrast controls nevertheless have their uses. Here I am whacking up the contrast as well as raising the brightness a touch.

technical details
Bronica Etrsi camera
Bronica 200mm lens
Fuji Velvia film

tools
Brightness/Contrast
Levels

keep in mind
Whenever you are experimenting with effects, save your work as a new file with a new name so you can go back to the original and start again should things go wrong.

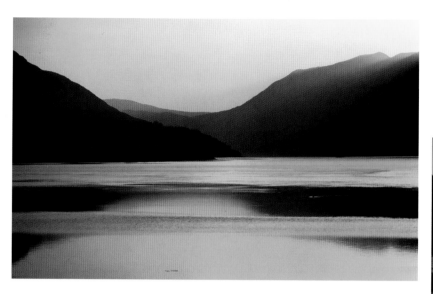

03 The result certainly has more impact than our original scan. Note that B&C adjustments (Image>Adjust>Brightness/Contrast) have no effect at all on the color of the image, and so are unlikely to cause color-related disasters in inexperienced hands.

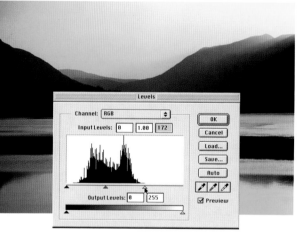

04 The Levels controls allow us much more freedom to go a bit crazy with color. By moving the black and white point sliders in towards each other and the grey pointer over to the right, we get massively increased contrast whereas lightening the midtones (by moving the grey slider to the left) gives a more natural level of contrast.

TIP BOX

In later versions of Photoshop (and some other applications) you can create a Levels, Colour Balance, Curves or Hue/Saturation 'Adjustment Layer', which allows you to experiment as shown above without affecting the color values of the underlying pixels (Layer>New>Adjustment Layer).

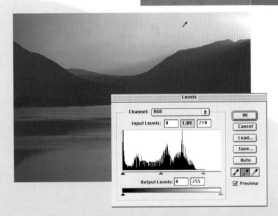

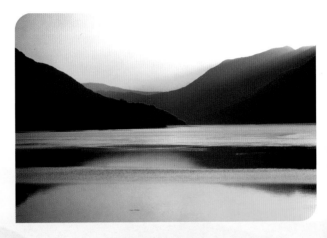

05 By deliberately clicking with the grey point eyedropper in non-neutral areas, we can very quickly see dramatic color shifts.

06 Experiment by clicking around the image with the eyedroppers and performing multiple Levels controls one after the other; you'll be amazed at the variations in color possible.

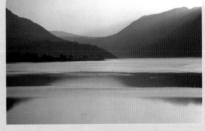

07 Here are just a few of the color changes I got by simply playing with the levels controls.

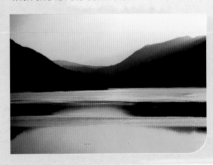

TIP BOX

If the reds in your digital camera shots look massively over-saturated and are bleeding into surrounding areas (a common problem) you can use the H&S controls to correct them. Choose 'reds' from the 'Edit' menu in the Hue/Saturation window and move the saturation slider a little to the left.

keyboard shortcuts

Adjust Curves	Control-M/⌘-M
Adjust Hue/ Saturation	Control-U/⌘-U
Reset (in Curves or Hue/Sat windows)	Press alt & click on reset

tools

Curves
Levels
Hue/Saturation

manipulate it

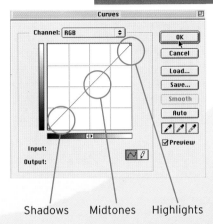

Shadows Midtones Highlights

01 One of the most powerful tools in the image editing arsenal is the Curves control. The horizontal axis of the graph represents the brightness levels of the image (called the input levels) from black to white. The vertical axis shows the corresponding output levels, also from black to white. If the graph is a straight line (as here), the result of clicking on OK will be no change to the image.

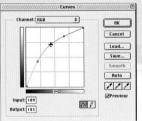

02 By clicking on the curve and dragging the central section upwards we can lighten the midtones without affecting the highlights and shadows dramatically, thus reducing contrast. The curve can have multiple anchor points added for fine tuning of contrast and brightness.

TIP BOX

You can remove anchor points you have added to the curve by dragging them off the graph in any direction.

Hue and Saturation The color of an image is most commonly described in terms of a mixture of red, green and blue light. One of the many alternatives is to assign values for the Hue (color), Saturation (strength) and Lightness of each pixel. The Hue/Saturation controls can be used to make dramatic or subtle changes to the overall color of an image.

The H&S dialog splits the image up into three components representing a color wheel. The Hue slider moves around the wheel, and the Saturation slider moves closer or further away from the center. The final slider, Lightness, shifts the entire wheel between all white and all black and is not normally used as much.

This diagram shows the color wheel at 50% Lightness. The Hue and saturation values stay the same, but they are much darker.

The Colorize option replaces all color with a toned greyscale effect. For more on this see pages 100-101.

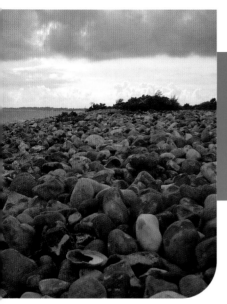

Selective exposure

Most of the time you can sort out basic exposure problems using the techniques described over the last few pages. But what if different areas need different levels of correction? Simple. Using masking and selection tools we can isolate areas of the image before making any changes.

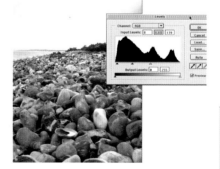

manipulate it

shoot it

01 Using a wideangle lens in vertical (portrait) mode allows you to capture loads of foreground. The distortion caused by the short focal length also distorts scale, making objects nearest the lens disproportionately large. This image is typical of raw digital camera files: dull, slightly underexposed and lacking contrast. The automatic exposure system has also been confused by the expanse of bright sky in the middle of the frame.

02 Using our normal methods of exposure correction, we can lift the foreground nicely, but in doing so we lose all that lovely cloud detail.

03 The answer is to isolate the foreground. In this case the easiest way to go about making the mask is to first select the sky (it has more continuous tone and less detail than the pebbles). Use the shift key to build up the selection using the Magic Wand. The Select>Grow and Select> Similar commands can also be useful . Invert the selection (Select>Inverse).

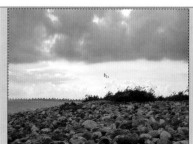

technical details
Olympus C-21
Digital Camera
Adobe Photoshop 5.5

tools
Magic Wand
Smooth Selection
Quick Mask
Levels

keep in mind
This technique is most commonly used for balancing out the difference in brightness between the sky and the foreground of an image. For more detailed lightening and darkening of areas of an image try the Dodge and Burn tools (see page 54-55).

04 Unless you are very lucky you'll need to tidy up the mask. Enter Quick Mask mode (press Q in Photoshop) or choose the 'Edit Mask' or 'Paint on Mask' option in other applications. Ensure the mask perfectly matches the horizon as a poor selection will be very obvious.

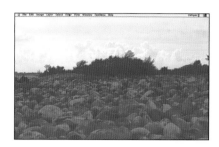

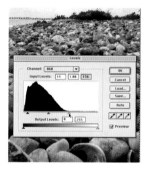

05 Turn the mask back into a selection (press Q again or turn off the paint on mask option). You can now adjust the levels on the foreground. In this instance I also re-inverted the selection and increased the contrast in the sky slightly.

Modifying Selections In this exercise we have used the **Magic Wand** to create our basic selection. The problem with this tool is that it can produce selections with jaggy edges, especially when working on digital camera images that have been saved using JPEG compression (which tends to put a fringe of stray pixels on hard edges).

Applications such as Photoshop offer several ways to make selecting areas of an image easier and smoother.

With an active selection take a look at the Select menu. Here you'll find a variety of options. Feather puts a soft, blurred edge on a selection and should be avoided in situations like this. Much more useful are the Grow and Similar options, which expand the selection to other pixels with similar colors (the difference is that Grow only selects contiguous areas). Also useful are the options under the Modify menu item. Smooth is especially handy for removing the rough edges produced by the Magic Wand. Expand and Contract can also be useful for overcoming JPEG fringes around the edges in an image.

06 The end result: if you see a bright or dark line on the horizon you'll need to start again and try to get a selection/mask that more closely follows the horizon.

more...
Turn the page for more techniques for selective exposure control

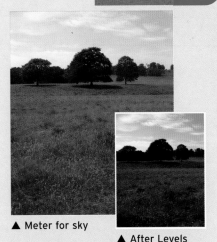

▲ Meter for sky

01 On very bright days the contrast of a scene is simply too high to capture the full range of colors in the sky and on the ground. The answer is to take two exposures at different exposures (using a tripod to make sure the camera doesn't move).

Both these shots were taken within 30 seconds of each other in auto mode with AE compensation to alter the exposure . Using Levels, it was then possible to get a perfect sky and a perfect foreground (insets).

▲ After Levels

02 Both images are then placed in the same Photoshop document as separate layers (the easiest way to do this is to open both files and use the Move tool to drag one onto the other).

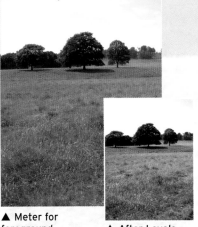

▲ Meter for foreground

▲ After Levels

03 Using the eraser in Brush mode all you need do now is to paint away the areas of the upper layer where the exposure is wrong. The screenshot above shows the top layer on its own once I'd finished. Above is the final result after Unsharp Masking.

keyboard shortcuts		tools	keep in mind
Adjust Levels	Control-L/⌘-L	Layers	This technique only works if the two expo-
Eraser tool	E	Eraser	sures are taken without either camera or
Increase		Levels	subject moving between them. Some cam-
Brush size]		eras offer an 'Auto Bracketing' function
Decrease			that can be very useful in these situations.
Brush size	[

01 Our final technique for selective exposure control uses Adjustment Layers, found in the full version of Photoshop as well as several other applications. The starting point is another digital camera shot. Again, using Levels to correct the brightness in the foreground causes the sky to burn out completely.

02 From the Layers menu choose New>Adjustment Layer. From the pop-up 'Type' menu choose 'Levels' and click OK. You will now see the standard Levels window. Move the sliders until the foreground brightness and contrast are correct (don't worry that the sky has disappeared).

03 Make sure the Levels is the active layer (click once on its name in the Layers Palette) and choose a large, soft-edged paintbrush and a foreground color of black.

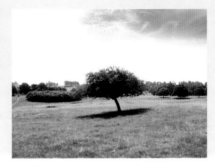

04 As you paint you create a mask that blocks out the effect of the Levels alterations you made in step 2. Don't worry too much about getting the mask to match the edge of the sky exactly; this is a quick technique and as long as your brush is large enough (and has a soft edge) the results will be perfectly convincing.

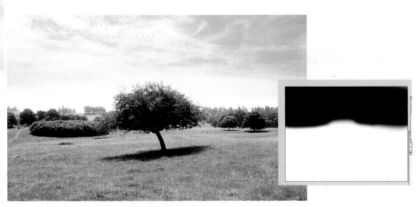

05 This is the final adjustment layer mask I created for the result shown above.

TIP BOX

Not all applications offer Adjustment Layers. Another quick way to 'paint on' selective exposure is to use the 'Undo Brush' (in Photoshop called the History Brush). This allows you to change the brightness then paint back to the previous state (in other words to before you lightened the image) selected parts of the frame.

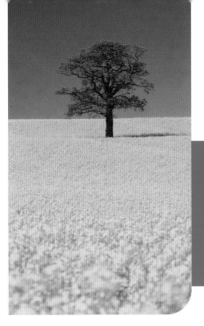

Cropping

It may be one of the simplest edits you can perform on an image, but a little judicious re-framing can add a new dynamic to a landscape or concentrate attention on the main subject.

manipulate it

01 There really is nothing more to cropping an image than clicking with the crop tool and dragging out a rectangle to define the new frame. Some applications, such as Adobe Photoshop 6.0 (shown here), make the process even easier by greying out areas outside the new crop.

02 Although most cropping is to either create a more panoramic frame or simply to 'tighten' the composition (whilst preserving the original proportions), feel free to experiment. Remember that a vertical panoramic frame can look very dramatic. Most applications allow you to rotate the cropping frame, but take care, it may look like a mistake!

technical details
Pentax 6x7
55mm lens
Fuji Velvia film
polarizing filter

keyboard Shortcuts
Crop tool C
Perform crop (after
selecting frame) **Double-click or enter**
Marquee M
Select Inverse Control-Shift-i/ ◢ -Shift-i

navigator
Stitched panoramas p72-75
Border and edge effects p86
Straightening horizons p57

03 For a more adventurous crop you need to forego the cropping tool altogether and use the selection tools to create the shape of your new frame. Here I have used the simple circular marquee to select the central area of the frame. Then all you need to do is simply inverse the selection (Selection>Inverse) and press clear (backspace).

TIP BOX

■ Square crops can be very effective for landscapes, as the popularity of 6x6cm cameras for this type of photography illustrates.

■ Photographs taken in landscape orientation can easily be converted to portrait (and vice versa) using the cropping tools.

■ Remember that cropping removes pixels, and if you remove too much you may be left with an image with too low a resolution for satisfactory printing. If you are scanning your pictures and intend to crop, make sure you increase the scanning resolution enough to make up for the loss of pixels.

■ If your digital camera only has a wideangle lens but offers a digital zoom, don't use it (the zoom that is!). Shoot instead at the best quality setting and use cropping to create the same effect with less loss of quality.

■ Check out the section on border and edge effects for tips on adding special effects to the edges of your crops (page 86).

■ As with all digital imaging, experimentation is key to getting good results when cropping for creative effects.

04 One of the most effective uses of cropping is to create a panoramic frame. In this case the image was shot specifically with the intention of cutting out a large part of the top and bottom of the image. The beauty of digital photography is that you can plan for this kind of editing when you shoot, creating stunning panoramas without carrying any special equipment. Other times, the cropping to panoramic format only occurs after the picture has been taken and scanned.

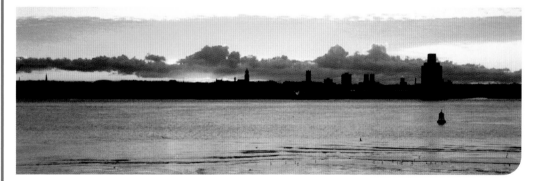

Removing elements

No matter how hard we try, there are always going to be times when we shoot a landscape that has something in it - a person, a road sign or a car - that we would much rather wasn't there. Once again digital imaging comes to the rescue. This rather extreme example shows just how much can be done remarkably easily.

shoot it 📷

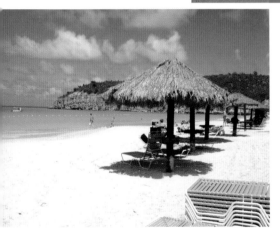

Our starting shot in this instance is a fairly nondescript beach scene snapped in Antigua. The photo was one of a large number grabbed whilst walking around with a digital camera. The intention was to capture as many nice blue cloudy skies as I could for possible use in future montages. As a photograph itself it has little to recommend it, from the obtrusive recliners in the bottom right to the rather alarmingly angled horizon. However, it does illustrate the principles involved in removing unwanted elements.

Before starting I tweaked the brightness and contrast and straightened the horizon using the method described on page 57.

01 The main tool used for this kind of work is the Rubber Stamp (also known as the Clone tool). The Clone tool allows you to paint over one section of an image using pixels from another section. In the example above, I have cloned the pixels inside the red oval onto the area in the blue oval.

technical details	tools	keep in mind
Olympus C2040 Digital Camera Program exposure Adobe Photoshop 5.5	Rubber Stamp (Clone tool)	Remember that you can clone from different areas and use different brush sizes to get the perfect result.

02 First set a 'source point', the pixels you want to clone from. To do this hold down the alt (option) key and click. Let go of the alt key and start to paint somewhere else. The screenshot right shows the source point (the little cross) and the brush itself (the circle) as I start to paint away the loungers. Note that the source point moves with the brush.

TIP BOX

In Photoshop's preferences (Edit>Preferences>Displays & Cursors) set the brush cursors to 'Brush Size'; it makes using tools like the rubber stamp much easier, as you can see the size of the brush in use.

03 By using a variety of source points and brush sizes I have been able to remove the loungers and the people in the sea.

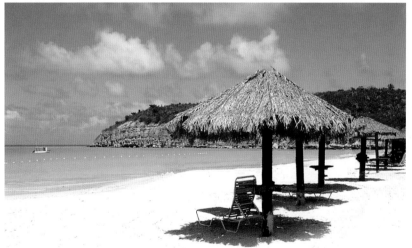

04 I have used a small brush to clone the sand in the blue circle over the area in the red circle, thus removing the people.

keep in mind
The techniques described on these pages are most often used to remove small elements – usually man-made – from otherwise unspoilt scenes. The best idea is to avoid getting them in the frame in the first place!

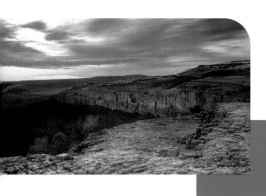

Dodge and burn

The old darkroom techniques of dodging and burning - giving different areas of the frame more or less exposure to selectively lighten or darken them - took years of practice. Fortunately, the digital equivalents are much easier to master. And they work just as well in color as in black and white...

scan it

01 This beautiful scene is a little flat for two reasons: the auto exposure in the scanner has not quite got it right and the expanse of cloud across the whole sky has produced rather featureless lighting.

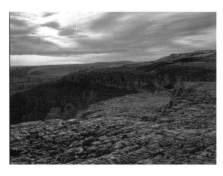

manipulate it

02 Using Levels to lift the foreground causes the sky to get burnt out and is no improvement at all.

03 The perfect tool for this job is the Dodge/Burn tool. Dodging (the little black circle on a stick) lightens the area you paint; burning (the little hand) darkens it. Double click on the Dodge/Burn icon in the toolbar to bring up the tool options. Set the mode to Midtones and reduce the exposure to something around 30%. Some applications also have a third tool in this section: the sponge. This is used to saturate or desaturate areas (make the color stronger or weaker).

technical details
Wista Field camera 5x4
150mm lens
Fuji Velvia film

tools
Levels
Dodge and Burn

keep in mind
It is better to use a low exposure and build up the lightening and darkening than to go rushing in at full strength. It is easy to get carried away and make a total mess, especially when working on color images (dodging and burning at high strengths can have some weird and unpredictable effects).

04 Start to paint areas with the Dodge or Burn tools to lighten or darken them. Here I have just started to lighten the stones.

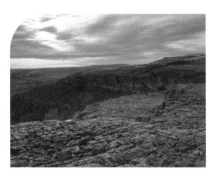

06 The Sponge tool's options are simple: saturate to increase color, saturate to remove color. The pressure setting defines the strength of the tool's effect.

07 The final image. As well as 'painting with light' I have saturated areas of the sky and the green areas of the landscape. Dodging and burning can in the right hands have both subtle and dramatic effects.

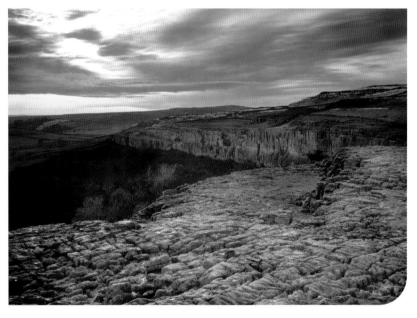

05 Somewhat later in the process, areas of the sky have been darkened to increase contrast and parts of the foreground have been lightened to give the impression of light coming through the clouds.

TIP BOX

Use the tool options to restrict the effect of your dodging and burning to highlights, midtones or shadows. With a little experimentation you'll soon learn what works when.

Changing perspectives

Photographing buildings from the ground inevitably results in distorted perspective in the form of converging verticals. Although this can be used to great pictorial effect, if you don't want it, this distortion can be very difficult to remove using conventional means.

manipulate it

03 Drag each lower corner inward until the sides of the building look straight. You can use a guideline in Photoshop to get the sides perfectly vertical, but to be honest assessing the distortion visually should be accurate enough.

shoot it

01 The taller the building, the more you have to angle the camera up and the stronger the distortion of the verticals. If you can't get further away and don't have access to expensive shift lenses, then the result of shooting a tall building is always going to be like this: verticals that get closer together towards the top of the frame.

02 First up select the entire image, choose Select>All (or press control-A/⌘-A). From the edit menu choose Transform>Distort.

technical details
Mamiya RB 6x7 camera
50mm lens
Ektachrome 64 film

tools
Free Transform or Distort
Cropping
Clone tools

keep in mind
The best way to deal with converging verticals is simply to avoid them in the first place. This is easy with a 5x4 view camera, not so with a fixed lens compact or even a 35mm SLR unless you shell out for a shift lens.

04 The distortion will leave white spaces in the bottom corners. Crop the image as shown above; you can leave a little of the white showing and clone over the white areas using detail from elsewhere in the frame.

05 The end result: the distortion is removed without losing too much of the detail in the rest of the frame.

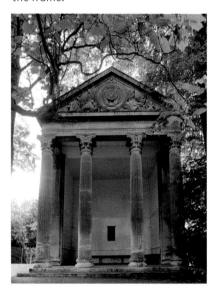

TIP BOX

Other common lens distortions (barrel and pincushion) can be corrected to a certain extent with pinch and spherize filters, but you may need to buy a special Photoshop plug-in to do it with any real success.

Straighten up Whether due to a wonky scan or poor composition, a slightly skewed horizon is a real distraction from what could otherwise be a winning shot. Here's how to correct it.

01 Photoshop has a very handy Measure tool. Press U to select it. The Measure tool needs to be used together with the Info palette (access from the View menu). Use the tool to draw a line along the horizon.

02 The Info palette will display information about the line you just drew. What we are interested in is the angle.

03 We can now enter this angle into the Image> Rotate Canvas>Arbitrary box (Photoshop will automatically put the figure from the Info palette for you).

 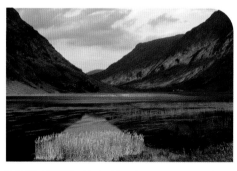

04 Click on OK and re-crop the image to remove the white areas created by the rotation.

Sometimes, rather than remove distortion, we actually want to introduce it for effect. The fisheye effect works particularly well with shots like this one, but it can only be achieved using conventional means without expensive hardware and is nigh on impossible using a fixed-lens camera.

01 Our starting point is a digital camera photograph taken in less than perfect conditions from the top of the Empire State Building. The wideangle end of the zoom has already caused some distortion, and the slightly hazy weather has reduced contrast unacceptably.

manipulate it

02 The first job is to add a little contrast and color to the scene. In this case the Auto Levels command (Image>Adjust>Auto Levels) did the job first time. This image was also sharpened.

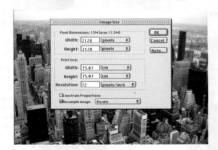

03 We now want to distort the image to make it square (this makes creating a circular fisheye image easier, and ensures we don't lose any of the detail on the left or right sides of the picture). Using the Image Size command change the width to match the height, making sure the 'Constrain Proportions' option is unchecked (off).

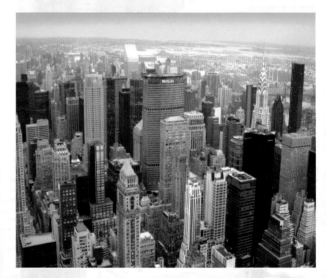

04 As the sky is all white, use a large paintbrush set to Multiply mode and a Low Opacity (say 20%) to paint some light blue across the top of the frame.

technical details
Fuji FinePix 6800Zoom
Digital Camera
Wideangle end of zoom
Adobe Photoshop 5.5

tools
Image Size
Spherize
Lens Flare
Auto Levels

keep in mind
Not all landscapes will work as well as this one when given the fake fisheye treatment.

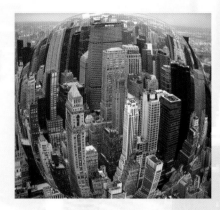

print it

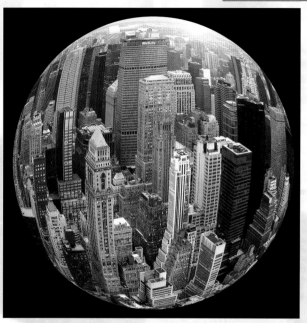

05 Next, select the entire canvas (Select>All). From the filter menu choose Distort>Spherize. Set the mode to 'normal' and the amount to 100%. Click on OK.

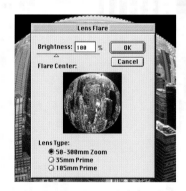

07 For added realism, re-invert the selection and run the lens flare filter (Filter>Render>Lens Flare) on your image. Place the flare centre in the upper right of your circular image and set the brightness to 100%.

06 Use a circular marquee to draw a selection around the distorted area (hold down the shift key whilst dragging to get a perfect circle). Choose Select>Inverse and then fill using black paint.

08 And there we have it. Although the angle of view is not as wide as a true fisheye, the subject matter, along with the squeezing performed in step 3, means the result looks pretty convincing. If your original image has enough detail, print the fake fisheye as large as you can onto high quality photo paper, then trim away any white borders left by the printer before mounting or framing.

TIP BOX

Although it is recommended to use Manual Levels controls, it is always worth trying Auto Levels first to see what it produces.

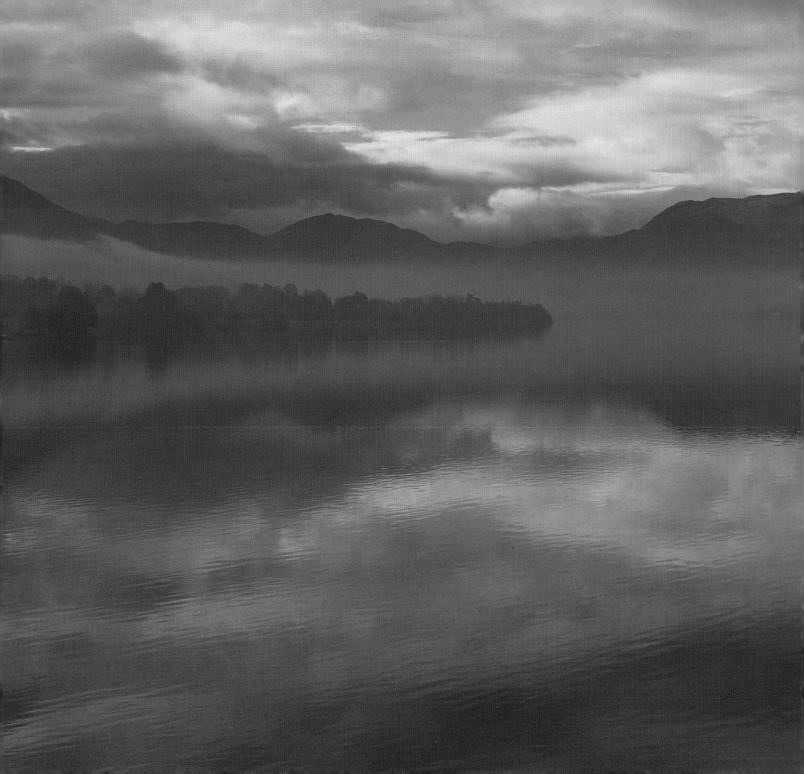

CHAPTER THREE

SIMPLE TIPS AND TECHNIQUES

Graduated filters

Graduated tint filters have long been popular with landscape photographers wanting to add a little color to skies. The only problem is that unless you are prepared to shoot several versions of the same scene - with and without the grad filter - the effect can't be 'undone' or altered at a later stage.

scan it

We're going to use this simple scene for a little experimentation with graduated filter effects. The original was shot on medium format film and digitized using a flatbed scanner (at 600dpi). The scan was cleaned up and sharpened in Photoshop before being saved.

manipulate it

Create New Layer

01 As we want any edits we perform from now on to be 'nondestructive', we'll first create a new, transparent layer above the background layer (which contains the photograph itself).

02 With the upper layer active, use the Gradient tool to create a Linear Gradient from the foreground color (black) to transparent. Use the Gradient Options Palette to make these settings (you can bring up the palette by double-clicking on the Gradient tool icon in the toolbar).

technical details
Wista Field camera 5x4
150mm lens
Fuji Velvia film

tools
Gradient tool
Layers
Hue/Saturation
Blending modes

keep in mind
If your application does not support gradients to transparent, use a standard black to white gradient. This will restrict slightly the blending modes you can use. For a 'normal' color grad-uated tint use Multiply mode, which works fine with a black to white gradient.

03 With the upper layer still active, choose Hue/Saturation from the Image> Adjust menu. Click on the colorize option and move the sliders around until you get a color you like.

print it

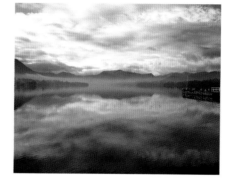

04 Change the mode of the upper layer (the one containing the gradient) to Overlay and adjust the opacity of the layer until you are happy with the result.

06 My final choices for printing: the top version uses a blue tint with the layer at 100% opacity (mode: Color Burn) and the lower one uses a pink tint, 100% Opacity Blend mode set to Multiply.

05 You can always alter the color of the gradient by returning to the Hue/Saturation dialog. Altering the blending mode and opacity of the upper layer gives endless variations.

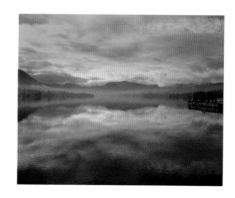

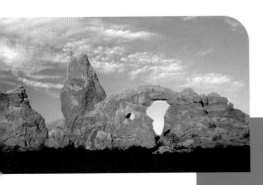

A new sky

It's one of the most common digital imaging tasks: replacing a featureless sky with something a little more impressive. The basic technique is very simple, but does require a little attention to detail. The key to a convincing result is to create a mask that perfectly fits the skyline in your original image.

shoot it

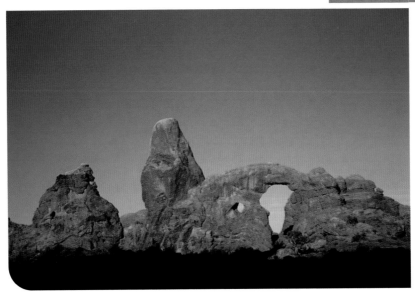

01 We'll start with a picture that already has a blue sky, although the techniques described are equally applicable to shots where dull weather or overexposure has left you with that most unappealing of skies – the dull grey expanse.

To start we need to select the entire sky area.

technical details
Canon EOS5 body
24-85mm lens
Fuji Velvia film

tools
Magic Wand
Quick Mask/Edit
Mask
Paintbrushes and
Erasers

keep in mind
Poorly masked montages will look
totally fake, although if you don't print
too large you can get away with quite a
rough cut out.

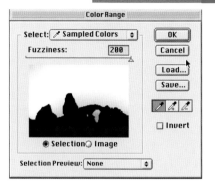

02 Most people would leap for the Magic Wand for this task, but here I decided to use one of Photoshop's neat little tricks: the ability to make a selection based on a range of colors.

First define the 'sampled color' by clicking in the blue of the sky. The 'fuzziness' slider defines how wide a range of colors is selected. You can also use the eyedropper with the '+' next to it to add extra colors to the selection. The preview image shows the masked area. Click on OK to apply the mask and zoom in to examine the selection; you will probably find it needs tweaking.

03 The easiest way to clean up a complex mask like this one is to edit it directly with your application's paint tools. Some applications call this 'Paint on Mask' or 'Edit Mask'. Photoshop (as used here) has 'Quick Mask' mode. To enter Quick Mask mode simply press Q or click on the icon at the bottom of the toolbar.

TIP BOX

The secret of a convincing and seamless join lies in spending some time getting the mask to match the image as closely as possible. Zoom in to the image and use a small paintbrush to touch up any areas where the selection tools you used to generate the mask in the first place have not quite got it right. If you used the magic wand tool you may also want to smooth off the entire edge, as these tools tend to produce rather harsh edges to masks. Remember you can use a combination of brush sizes and softnesses to perfectly match the mask to the image.

shoot it

04 Once you are happy with the mask you have created turn it back into a selection (in Photoshop just press Q to exit Quick Mask mode). We want to place the newly cut out foreground into a new layer, so first invert the selection (remember we initially selected the sky area, not the foreground). Some applications, such as Photoshop, allow you to create a new layer directly from a selection (Layer>New>Via Cut). If not, you need to create a new transparent layer and cut/paste the selected pixels into it. The screenshot above shows the layers palette after the foreground has been cut out and placed in a new layer. The grey and white checkered area of the thumbnail indicates areas with transparent pixels.

05 Now for the new sky. By always carrying a digital camera it is possible to quickly collect a wide selection of shots of skies, objects and scenes that - whilst of little interest on their own - can become an invaluable resource once you are playing around in your digital darkroom. This sky has nice cloud detail and, equally importantly, is a similar blue to the original sky from our first image. This helps making a convincing montage considerably easier.

keyboard shortcuts		**tools**	**keep in mind**
Zoom	spacebar and control	Levels	Bright new skies only look
Edit in Quick Mask	Q	Layers palette	realistic if the original scene
Wand tool	W	Quick Mask	is bright and well saturated
Levels	Control/apple - L	Hue & Saturation	itself.

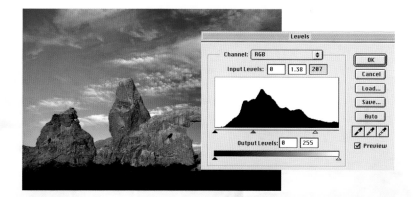

06 With both documents open (the original scene and the new sky), it is now a simple matter of dragging the new sky onto our original image. This will create a new layer. You may need to stretch the new sky to fit, although if both pictures are shot with the same digital camera they will already be the same size. Using the Layers palette (as shown above), drag the layer containing the new sky to below the layer you created in step 4 containing the cut out foreground. At this stage you can delete the original background layer if you want; doing so will save memory and disk space.

07 It is very unlikely that the brightness and contrast of the new sky will exactly match the scene in the layer in front of it. Here I am adjusting the white and black points and overall contrast of the new sky so it visually matches the rocks in the foreground.

08 You may also need to match the color balance of the sky to the original scene. The easiest way to make slight color adjustments in these cases is using the Hue/Saturation/Lightness controls. All it took for this image was a Hue adjustment of +9.

TIP BOX

Masking foliage is notoriously difficult. Don't be tempted to 'feather' your selections in such cases; nature rarely creates semi-translucent leaves or branches. Instead, try using a textured brush to create the mask in difficult areas.

Reflections

Sometimes the real world just doesn't do what you want it to. Unless the light, the angles and the water are just right it is rare to see the buildings on a waterfront reflected at all, never mind in the kind of perfect symmetry we'd really like. Time to get to work with a little creative digital darkroom trickery...

shoot it 📷

01 This quick snap of the south Manhattan skyline was just that: a grabbed shot taken by pointing the camera between two heads on the Staten Island Ferry. A preponderance of grey sky and water has produced a flat, almost monochrome scene with only the barest reflection of the skyline in the water.

manipulate it ⬉

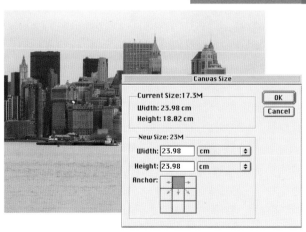

Canvas Size

Current Size:17.3M
Width: 23.98 cm
Height: 18.02 cm

New Size: 23M
Width: 23.98 cm
Height: 23.98 cm
Anchor:

OK
Cancel

02 Our first job is to sort out the slight underexposure and low contrast using the Levels controls (see pages 36-39). We also need a bit more water to fit in the whole reflected skyline. Use the Image>Canvas Size menu to make height the same as the width, putting the original image at the top of the frame. I then moved the image down the canvas slightly and used the Clone tool to 'fill in' the water.

technical details
Fujifilm FinePix 6800
Zoom
Digital Camera
Adobe Photoshop 5.5

tools
Levels/histograms
Cloning
Canvas Resize
Gradient tools
Layers

keep in mind
Your original scene need not necessarily be on the waterfront in reality. You can use this technique to add a fake lake in front of any building.

03 The sky in this image is typical of an overcast day: completely featureless. We can create a new one from scratch that will recreate the effect of a blue graduated filter on the camera lens. First, select the entire sky area; the Magic Wand can do the job in a couple of clicks. Use Photoshop's Select>Modify>Smooth menu option to soften slightly the rather rough edge the Magic Wand tends to produce.

04 With the selection still active, choose foreground and background colors similar to the blues shown above. Click on the gradient tool and – if options are available – choose a standard linear gradient between the two colors.

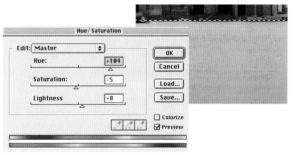

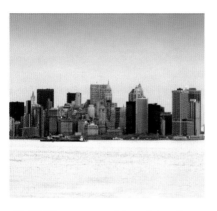

05 We can now click and drag to create a nice graduated tint between the two blues chosen. The tint replaces all the pixels within the selection made in step 3.

06 Now we need to add a little sparkle, or at least a little color, to the water. First, isolate the water area with a selection. With a perfectly straight waterline like this it is a simple matter of dragging a rectangular marquee around the water, but if your waterline is not so flat you'll need to use slightly more convoluted selection/masking techniques. To bring up the blue of the water in this picture I increased the lightness slightly and shifted the hue dramatically (+104 to be exact). I also reduced the saturation a little for a more natural color. Keep the selection you just made active, you'll need it for the next step.

TIP BOX

Always make sure you have the live preview option selected when making adjustments such as Hue/Saturation; the only way to judge what works is through visual feedback.

08 The new layer now needs to be flipped through 180 degrees (in Photoshop choose Edit>Transform> Flip Vertical).

07 With all the preparation done, now it's time to create the reflection itself. We want a new layer containing a copy of the scene above the waterline. This is actually the inverse of the selection created in step 6, so all you need do is to choose Select>Inverse. Applications such as Photoshop often support the direct creation of new layers from selections (Layer>New>Via Copy). If not, copy, create a new transparent layer and paste.

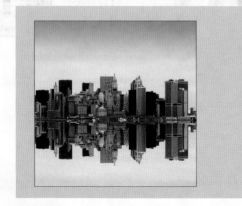

09 Use the Move tool to align the new layer (the upside down reflection) with the original. This is much easier if the waterline is straight.

keyboard shortcuts

Layer via copy	control-J/⌘-J
Gradient tool	G
Hue/Saturation/ Lightness	control-U/⌘-U

tools
Layer
transformations
Layer modes
Ripple filter

10 Obviously we want to see the water that is supposed to be reflecting the buildings. To get a realistic effect both the opacity and the blending mode of the top (reflection) layer need to be changed. You will need to experiment a little, but a good starting point with dark buildings is Darken mode and an opacity of between 40 and 50%.

11 For a final touch of realism, apply the Ripple filter to the reflection layer; use a high Amount unless your image is very low resolution.

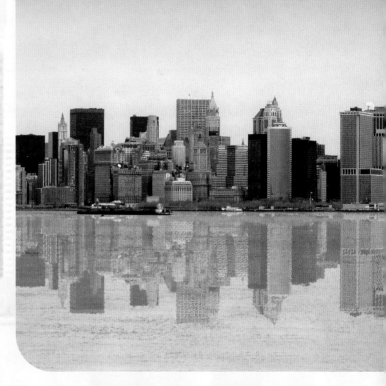

12 And there we have it: not, perhaps, the most realistic scene on earth, but a real improvement on our rather hopeless original.

TIP BOX

Experiment with abstractions created from multiple reflections of a scene for a kalidescope effect.

Panoramas

By combining several exposures into one, it is possible to create stunning panoramas that would require highly specialized equipment, if attempted using conventional means. For this illustration we'll use an inexpensive stitching application.

shoot it 📷

01 The panorama is made up of a sequence of photographs that are 'stitched' together using special software. The photographs must be taken on a tripod, which must be as level as possible. This ensures the final panorama is not distorted or skewed. You should ideally look for around a 20% overlap between each frame as you pan the camera around the scene. Use a mid-wideangle lens, but avoid using a very wide (under 28mm) lens.

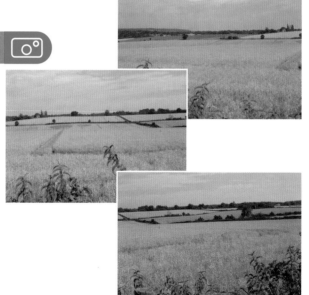

02 These shots are taken on a digital camera, but they could equally well be shot on film. If scanning, you need to ensure the individual frames are as closely matched as possible in terms of brightness, contrast and color. Locking the exposure when shooting can also help.

technical details
Fuji FinePix 6900
Digital Camera
Spin Panorama 1.0
Photoshop 5.5

tools
Stitching application
Color balance &
Levels controls
Clone tool

navigator
Turn to page 50 for tips on cropping single images to panoramic format.

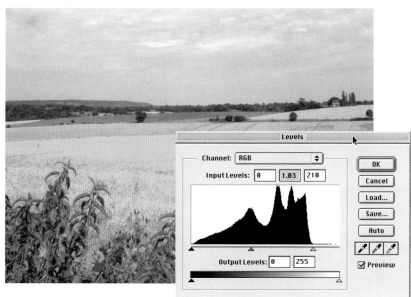

04 The next step is to import all your individual frames into the application. The application should automatically place the individual frames into the right order. If they are out of sequence you can re-order them by simply clicking and dragging each shot to its correct position. Click on the 'Stitch' tab (remember, I am using Spin Panorama; other applications will look different, but they all work in exactly the same way).

03 Each frame needs to be individually adjusted to ensure the closest possible match for both color and brightness/contrast. If you are lucky the shots will already all be very similar. Save all the files (named numerically from frame 1; this helps keep them in the right order). Now open your stitching application.

TIP BOX

■ For printing purposes, you will want to save your image as a JPEG or TIFF file. This generates a panoramic image that can be printed onto special paper using an inkjet printer.

■ You can create a full 360° panorama and save it as a QuickTime VRTM movie that viewers can pan around and zoom into. These can be placed on websites or into presentations for a uniquely interactive view of an entire vista.

■ Stitched panoramas can be huge; bear this in mind when scanning or shooting your individual frames. For example, a stitched panorama made up of four 1200x1600 frames could end up as 1100x6000 pixels: a file size of nearly 19MB.

■ For a panorama with more height, use the camera in portrait mode and rotate the images (to upright) before stitching. You will obviously need to shoot more frames to get the full panorama.

■ Don't forget, you can easily create panoramic style shots from existing single frames by simply cropping to a letterbox shape.

keep in mind
There are several image editing applications that offer panorama stitching as an option, including Photoshop Elements and MGI Photosuite. Here, I am using an inexpensive standalone product, PictureWorks Spin Panorama.

05 Although most applications offer an automatic stitching facility, this doesn't always work. Spin Panorama has a 'SmartStitch' button that sometimes produces perfect results first time. Click on it to try. If the result is good, then carry on to step 6. If not, you need to tell the application how to stitch the images. You do this by setting 'control points'. These identify details that are common to adjacent frames. In Spin Panorama the control points are shown as pairs of linked green circles. Carefully position each set of targets over the matching points.

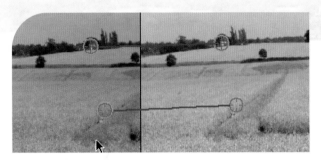

06 The panel at the bottom of the stitching window allows you to position the control points with pinpoint accuracy. The screen above shows an abandoned traffic cone that appears in two adjacent frames.

07 Once you have positioned both sets of control points for all the stitches, you can preview the result by clicking on the little red arrows above each join. If you are happy you can now proceed onto the next tab ('crop'). Unless you are very, very lucky, your stitched image will need to be cropped slightly due to small vertical misalignments. The program will automatically suggest the crop that preserves the maximum image information whilst removing the jagged edge caused by the stitching process. Once you are happy, click on the 'create' tab and choose a format in which to save the final image.

keyboard shortcuts
Zoom	spacebar and control
Rubber stamp	S
Select image	command L
Select brush	alt-click/option-click
Wand tool	W

tools
Levels
Rubber stamp
Paste into

keep in mind
By taking a full circle of images you can create a total 360 degree panorama, which can then be saved as a QuickTime VR movie.

08 Open the resultant file in Photoshop. You may find stitching errors, especially in areas where the wind may have moved grass or leaves. Use the Clone tool to disguise these areas as much as possible. Now is also the time to remove any unwanted elements, such as this traffic cone.

print it

09 Some inkjet printers allow you to replace the normal paper with special panoramic stock, either individual sheets or on a roll. This means you can print your panorama considerably larger than if you tried to fit it onto an A4 page.

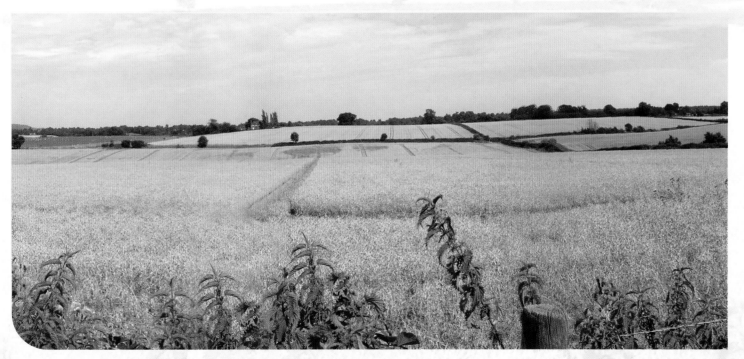

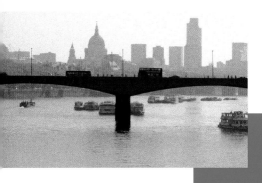

Moody Blues

By combining toning, brightness and contrast, and grain effects, it is possible to transform even the most uninspiring snap into something a little bit special.

shoot it

manipulate it

01 The starting point is a snapshot grabbed whilst walking to work along Hungerford bridge. By resting the camera on the bridge's handrail, it was possible to use a small aperture (f16) and a relatively long exposure (1/4s). This has left the image pretty sharp, but the camera's metering system has been confused by the rather hazy weather.

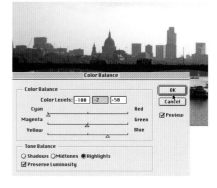

02 I wanted to get a real 'morning feel' by turning the whole image blue. I fiddled around with the color balance (Image>Adjust>Color Balance) for Shadows, Midtones and Highlights until I was happy.

03 Use the Magic Wand to select as much of the bridge as possible (use the shift key to add to your selection if necessary).

technical details
Nikon Coolpix 990
Digital Camera
Adobe Photoshop 5.5

tools
Magic Wand
Brightness/Contrast
Color Balance
Quick Mask
Add Noise

keep in mind
Adding grain to an image can disguise a multitude of sins, including softness and noise. The 'Add Noise' option is better than the 'Film Grain' filter, which can be a bit heavy-handed.

04 Turn the selection into a Quick Mask (press Q). If you are not using Photoshop this feature may be called 'Edit Mask' or 'Paint on Mask'. Use the paintbrush (and a selection of brush sizes) to clean up the Quick Mask until it is as perfectly matched to the bridge in the image as possible. In this case I used a tiny brush to add the lamp-posts to the mask.

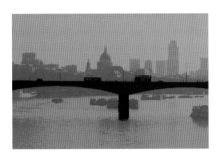

05 Turn the Quick Mask back into a selection (press Q again) and use the Brightness/Contrast controls to darken the bridge.

Invert the selection (Select> Inverse) and use the Brightness/ Contrast controls again to slightly lighten the 'non bridge' areas (I also reduced contrast).

06 At this point I returned to Quick Mask mode and extended the bridge mask to cover the water too. I then turned this into a selection, inverted it and lightened this upper area to add to the 'misty' feeling.

print it 🖶

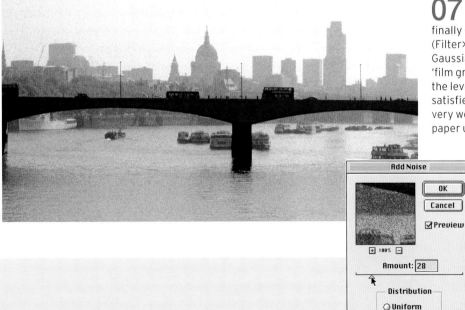

07 To finish the image, crop it to a more panoramic shape and finally – if you want – add a little noise (Filter>Noise>Add Noise). Choose the Gaussian option for a more natural 'film grain' feel and experiment with the level of noise until you are satisfied. This kind of image works very well if printed onto a textured paper using a color inkjet printer.

Montage/collage

They say a picture is worth a thousand words, but often it takes more than a single shot to tell the whole story of a place, especially a melting pot like New York City. Sometimes the only way to convey the many faces of a place is to combine several shots into one collage or montage.

shoot it 📷

01 The first step is to choose your component photographs. This is a 'lightbox view' of thumbnails from Extensis Portfolio, showing some of the many snaps taken on a trip to the Big Apple with a basic point and shoot digicam.

manipulate it

New

Name: Untitled –1 [OK]
 [Cancel]

Image Size: 36.7M

Width: 16 inches ▼
Height: 20 inches ▼
Resolution: 200 pixels/inch ▼
Mode: RGB Color ▼

Contents
○ White
○ Background Color
● Transparent

02 Create a blank document at the size and resolution you intend to print. Here I've opted for 16 by 20 inches at a resolution of 200 pixels per inch - perfect for ouput on an A3 inkjet printer. Give your new document a name and save it.

03 To add a photo, open the file (be it a scan or a digital camera shot) and using the Move tool simply drag it onto the new document and let go (un-click the mouse button). Each photo you drag into your master image will be copied as a new layer.

technical details
(NY Skyline at night)
Olympus OM4 TI
80-200mm Zoom lens
Fuji Velvia film

tools
Move tool
Layers Palette
Rulers and Guides
Layer effects

keep in mind
Collage is an excellent way of telling a story with pictures. For cityscapes such as this, try to include some people or closer details to give more of a sense of the atmosphere of the place.

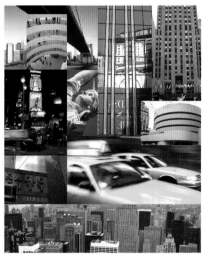

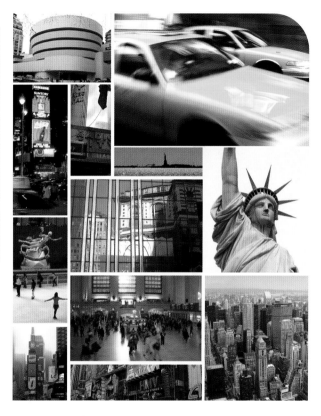

04 Inevitably you'll need to resize any photos you copy into the collage. Use the Layer>Transform command (control/apple - T) to stretch layers, but avoid scaling up (making images bigger) unless you really have to, as you will lose quality. Use the move tool to position each individual layer until you are happy with the overall composition.

05 Try to use a well balanced variety of colors, angles and shapes. Use the cropping tool on individual layers to create a more dynamic composition.

TIP BOX

Some applications, including Photoshop, allow you to line up the edges of the individual elements in your collage more accurately than by eye alone. First choose 'Show Rulers' and 'Show Guides' from the View menu. You can now drag non-printing guidelines from the vertical and horizontal rulers onto the image. By selecting 'snap to guides' from the same menu, you can set the application to automatically line layers up to guidelines ('snap' to them) as you move near to them.

06 If you prefer a cleaner look, don't use overlapping photos. Here I've used Photoshop's guidelines to create a structured, evenly spaced collage (see Tip box). Turn the page for more collage ideas...

technical details
(Yellow taxis)
Olympus OM4 TI
80-200mm Zoom lens
Fuji Velvia film

07 Don't feel the need to stick to the rigid format of the canvas you have created. Often a well-balanced collage of images works better if the composition is a little less symmetrical. The inclusion of a 'non landscape' shot – the flag – helps to capture the character of the place.

08 You can take this even further by using a single, semi-abstract shot as a background for the whole collage. First merge all the individual images into a single layer. Drag your new background image onto your collage and place it behind your new, single layer containing the montage. In this case I distorted the flag to fill the entire canvas.

09 To ensure the collage images don't get lost in the background, use the drop shadow option on the upper layer (the one containing all the photographs).

technical details	keyboard shortcuts		tools	keep in mind
(Bridge to Manhattan)	Zoom	spacebar and control	Move tool	Landscapes can make good col-
Olympus OM4 TI	Move tool	V	Layers Palette	lages too. How about shooting
35mm lens	Transform Layer	command/⌘-T	Layer effects	the same scene at four different
Fuji Velvia film	Alter Hue/Sat	command/⌘-U	Rulers and guides	times of the year?

New Layer...
New Adjustment Layer...
Duplicate Layer...
Delete Layer

Layer Options...

Merge Layers
Merge Visible
Flatten Image

History | Actions | Layers
Normal Opacity: 100 %
Preserve Transparency
Layer 10
Layer 18 Copy

10 For a classy, graphic look use the Hue and Saturation controls (with the Colorize option activated) to tone the individual elements of your collage. See pages 100-105 for tips on toning.

11 You can extend the collage idea by altering the transparency and blending modes of the individual layers to get a complex blend of images. Use a large eraser to remove parts of layers and, above all, experiment!

TIP BOX

Click on the 'Auto Select Layer' box in Photoshop's Options Palette to automatically select any layer you click on; this makes arranging the individual photos considerably easier.

technical details
(US flag)
Olympus OM4 TI
80-200mm Zoom lens
Fuji Velvia film

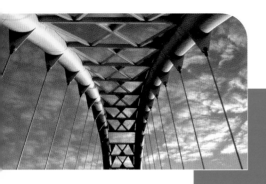

Selective mono

Sometimes we might not want to turn an entire image to greyscale. By selecting to leave some areas in full color we can isolate the main subject of the photograph and at the same time create a visually arresting picture. The secret lies in creating accurate masks for the areas we want to leave in color...

scan it

manipulate it

01 We'll start with a 35mm scan of a semi-abstract photograph of the Humber Bridge. The first step is to correct the brightness and contrast using the Levels controls (see pages 36-39).

02 We now want to select the entire sky. Start with the Magic Wand. This tool selects areas of similar color wherever you click it. We don't want the tool to be too fussy about how near the color is to the point where we click, so open the tool options (double click on the Magic Wand in the toolbar) and change the Tolerance value to 32. Click anywhere in the sky.

03 To extend the selection to the rest of the sky in a stroke use the Select>Similar command. This should add all the sky areas to the selection. If not, repeat the Similar command until the whole sky is selected.

| technical details |
| Pentax ZI P camera |
| 28-105mm zoom lens |
| polarizing filter |
| Fuji Sensia 100 film |

tools
Magic Wand
Modify Selection
Adjustment Layers
Hue/Saturation

keep in mind
Remember that by holding down the shift key when clicking with the Magic Wand you add to the current selection, rather than replacing it.

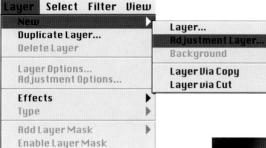

04 Choose Select>Modify> Smooth and enter a Sample Radius of 2 pixels to diminish jaggy edges.

05 From the Layer menu choose New>Adjustment Layer. This feature is not found in all image editing applications.

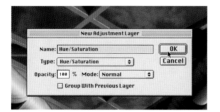

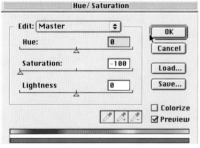

06 In the dialog box that appears choose Hue/Saturation from the pop-up Type menu. Click on OK.

07 You will now see a standard Hue/Saturation window appears. Slide the Saturation level down to 100%. You should see the sky area lose all its color.

08 You have now created an adjustment layer, which will appear in the Layers Palette. The layer consists of a mask based on the selection made in steps 2 to 4 and the Hue/Saturation changes you made in step 7. Click on the mask and use the eraser on it. You will see that where you erase the mask, the original tones are restored (before the H/S adjustments).

TIP BOX

To set the foreground (paint) and background (erase) colors to their defaults (black and white), press D. To swap the paint color for the background color, press X.

09 Making sure you are working on the mask itself (click on it in the Layers Palette), use a small, hard-edged brush to clean up any areas where the mask does not match the image.

10 Use a black foreground color (paint) to add to the mask (extend the greyscale areas) and white paint to remove pixels from the mask (extend the color area). Work at a high magnification and you will soon be able to get the mask just right.

11 You can go back and change the Hue/Saturation settings from step 7 at any point, even after saving, as long as you use a file format that preserves layer information (such as .PSD). To change the H/S settings simply double-click on the Adjustment Layer in the Layers Palette and enter new values.

TIP BOX

■ Fine editing is much easier if you change Photoshop's preferences to show the size of the brush you are using as you paint. Go to File> Preferences> Displays & Cursors and change the Painting Cursors setting to 'Brush Size'.

■ Not all applications support Adjustment Layers, specifically Photoshop LE (although Photoshop Elements does). If you can't use Adjustment Layers you simply need to get your selection perfected (using Quick Mask mode to tweak the edges) before removing the color with the Hue/Saturation controls.
■ This technique works best when only a small area of the image is left in color.

12 Images with adjustment layers can only be saved in Photoshop's own format (.PSD) – or .PSP if you are using Paint Shop Pro. To save as a Tiff you'll need to merge the two layers (Layer>Flatten Image) first.

keyboard shortcuts

Sample color	alt-click/option-click
Larger brush]
Smaller brush	[
Preferences	Command-K/⌘-K

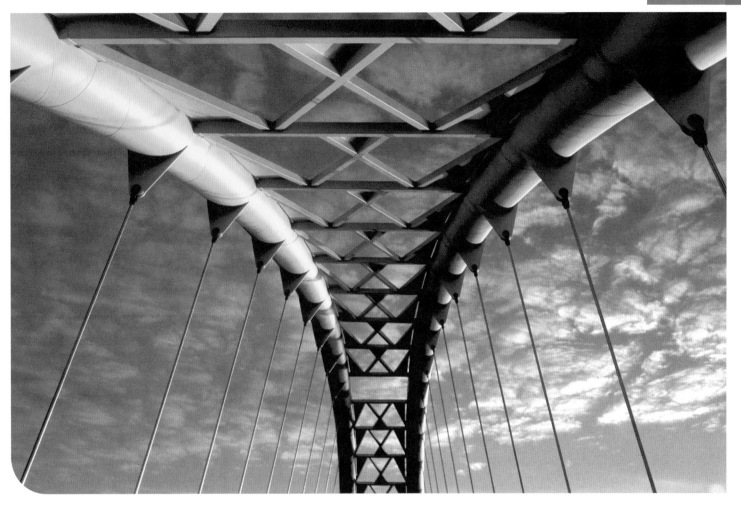

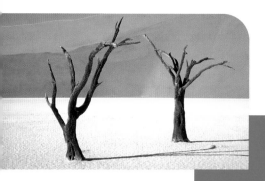

Over the edge...

Digital imaging applications give you powerful tools for easily adding creative borders to your photographs. Isolating the image with a good heavy frame concentrates attention on the picture itself, whilst special edge effects can in some cases become part of the appeal of the picture in their own right.

 manipulate it

01 Let's start with the simplest technique: placing a solid border around your photograph. Although some applications allow you to add fake wooden or other fancy frames to your pictures, we'll stick to the more tasteful traditional solid border. First up, choose a background color; this will be the color of your border (the screenshot above shows a background color of black in Photoshop's toolbar). Now open your image and choose Canvas size (in Photoshop you'll find it under the 'Image' menu).

02 The width and height values in the boxes show the current size of the picture. Decide how deep a border you require and increase the sizes accordingly. For example, if you want a 5cm border all round, add 10cm to each of the values (that's 5cm above and below and 5cm left and right). In the 'Anchor' section click on the centre box. This places your original image slap in the middle of the new, larger canvas. Now just click OK.

> **TIP BOX**
>
> For a more controllable border, place your image in a new layer before increasing the canvas size. Place the new layer behind the photo and fill with the color of your choice.

technical details
Canon EOS5 body
Canon 24-85mm lens
Fuji Velvia film

tools
Canvas Size

keep in mind
Although black or white borders are the safest for color images, you can use other muted, neutral colors if you prefer. This is especially true for black and white images, which work well with olive or warm grey borders.

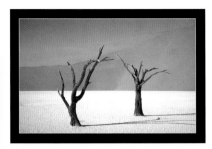

03 By performing steps 1 and 2 twice, first with a white background color and a small border, then with a black background and a larger canvas size, it is a matter of a few minutes' work to create an attractive 'keylined' frame.

04 Rather than simply adding a straight border or frame to your photograph, you might want to add an effect that works on the edge of the image itself. This could be in the form of a simple vignette or a textured rough edge, such as a 'torn paper' effect. Create a new layer in your image, behind the layer containing your photo. Fill this new layer with white and increase the canvas size of the document shown in step 2.

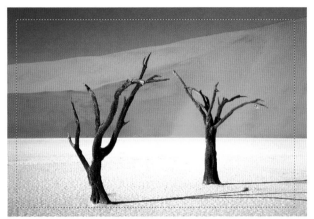

05 With the upper layer (that's the one containing your photo) active, drag a rectangular selection across the frame. It needs to be about half an inch inside the photograph's edges. Turn the selection into an editable mask (in Photoshop press 'Q' to enter Quick Mask mode).

06 Anything you do to the mask now will define what happens to the edge of your frame. Try applying a Gaussian blur (use the preview option to decide what Radius to use).

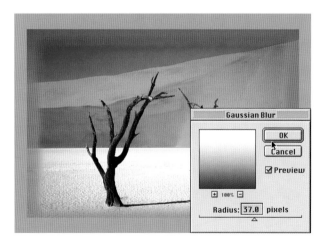

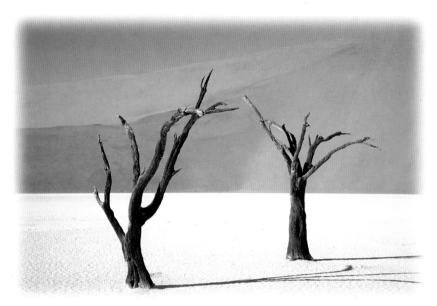

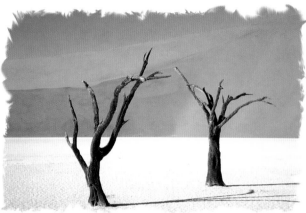

07 Turn the Quick Mask back into a selection (in Photoshop press Q). Invert the selection and press delete (backspace). This will remove the areas of the upper layer outside the rectangle created in step 5.

08 Experiments with different filters and effects at step 6 - filters such as Ocean Ripple and Glass (under the Filter>Distort menu) - can produce interesting effects (see below). The edge on the above image was created using the smudge tool on the Quick Mask.

keyboard shortcuts
Select all	control-a/⌘-a
Select Inverse	control-shift-i/⌘-shift-i
Smudge tool	R
Clear	backspace/delete
Marquee tool	M

tools
Selection tools
Smudge tool
Layers
Quick Mask/Edit
Mask

keep in mind
Try filling the background layer with a different color (such as black) for a bolder effect. Remember too, that you can add a drop shadow to the layer containing the photograph.

print it

10 Torn edges such as these work exceptionally well if you then carry the idea through to the printing stage. Try printing onto one of the many watercolor inkjet papers commonly available. The standard borders described in steps 1 to 4 are perfect for images you want to frame behind glass, in which case the best stock to print on will be high gloss photo quality paper.

09 For a 'torn edges' effect start by scanning a sheet of white paper torn to shape. Use Levels to ensure the paper is white and the rest of the frame black, select all and choose copy from the Edit menu. Open your photo, enter Quick Mask mode and paste the torn paper into the mask. You may need to scale the mask (choose Select All from Edit>Transform), but it shouldn't take more than a couple of minutes. When your mask looks like the one above simply follow the instructions in step 7.

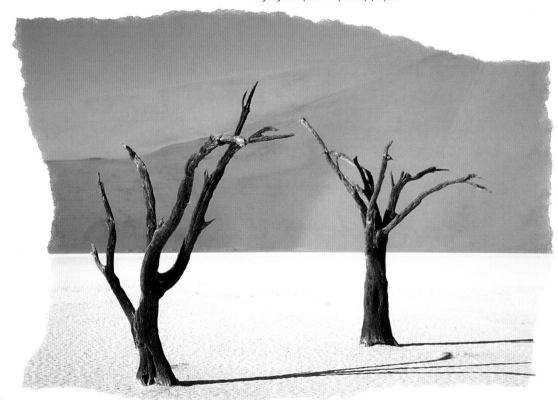

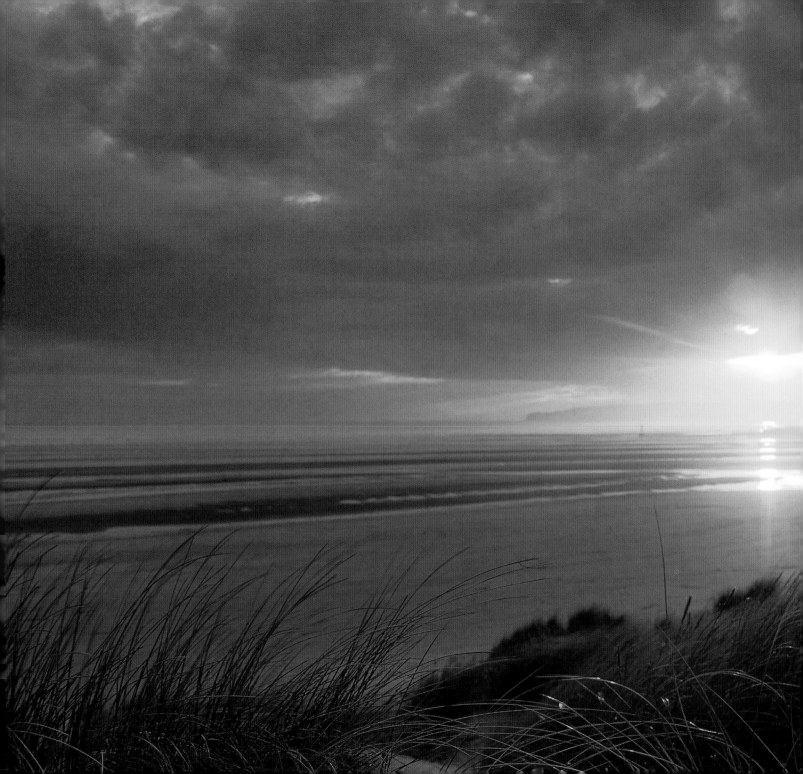

CHAPTER FOUR

SPECIAL EFFECTS

Filters & effects

Photographers use filters on the front of the lens to alter the picture as it is recorded onto film. In the digital darkroom we have the advantage of being able to use filters after we've taken the picture and have a level of control that is simply impossible to achieve in the real world.

01 All imaging applications offer a selection of preset special effects filters to transform your photographs. Some are subtle in their effect; many are very dramatic. More than a few stretch the boundaries of taste to breaking point. But the great thing about working on the computer is that you can experiment to your heart's content and - with some self-control - produce some interesting, unique and occasionally beautiful results.

manipulate it

02 Most special effects are found under the Filter menu. Some applications, such as Photoshop Elements, use a visual browser that gives an indication of what each filter does. By far the easiest way to get to grips with the many filters on offer is to set aside a couple of hours to experiment on one of your photos.

03 Most filters use a dialog box to offer a range of options and variables. Photoshop and most other applications don't give you much of a clue what the various sliders do, but a small preview window lets you see the effect on the image.

technical details
Mamiya RB 6x7 camera
50mm lens
Fuji Velvia film

tools
Filters

keep in mind
As well as software effects there are many special papers that can completely transform the image as it is printed. Look out for canvas, cotton, stipple and other inkjet media at photographic shops.

Effects filters can be split, very roughly into five groups: Natural Media (including paint effects), Distortions, Texture Effects (including noise and grain), Blur and Soften and Graphic Effects (into which I'm lumping all the zany ones that defy classification). In addition to these there are specialist filters, often purchased separately as 'plug-ins' that perform a single task. This could be anything from adding lightning to a scene to turning text into liquid metal or adding a coffee cup stain to an image (yes, that is a real one!).

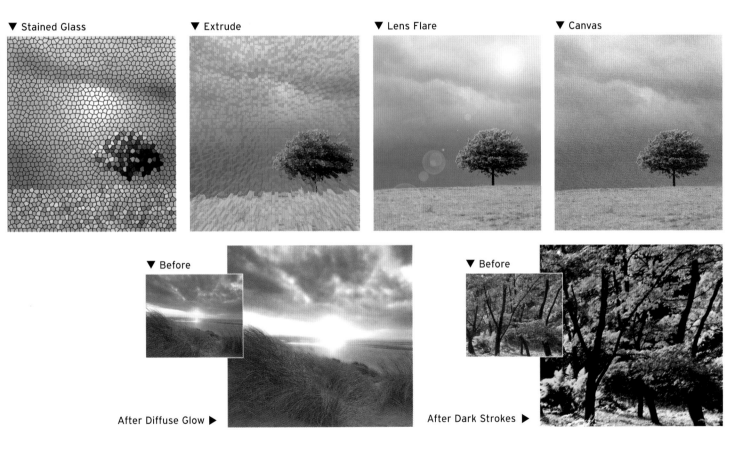

▼ Stained Glass

▼ Extrude

▼ Lens Flare

▼ Canvas

▼ Before

After Diffuse Glow ▶

▼ Before

After Dark Strokes ▶

all a matter of taste...
Some filters work better with certain types of images than others. Strong, graphic effects tend only to work with pictures having bold, simple shapes. Some filters, especially the wackier ones, simply are not suitable for 99% of landscape photographs (see right).

more...
Turn the page for some ideas on using special effect filters on your photos.

technical details
Mamiya RB 6x7 camera
250mm lens
Fuji Velvia film

Getting creative

You'll soon get bored of simply running the built-in effects filters on your photographs. For some unique results you need to be a little more creative in how you use the many tools at your disposal. Here are a few ideas to get you started.

 manipulate it

01 One popular way of extending the effects possible with filters is to run them on a duplicate layer, which can then be made to interact with the original image in a myriad of ways. The first step is to duplicate the layer containing your photograph. To do this simply drag its thumbnail to the 'New Layer' icon at the bottom of the layers palette.

02 Now run a filter on the new upper layer. Here I'm using the Radial Blur filter (Filter>Blur> Radial Blur), set to 'Zoom' mode.

03 The final step is to change the blending mode of the upper layer. Multiply, Screen, Overlay and Lighten tend to produce the most attractive results.

TIP BOX

Photoshop (version 5.5 and above) offers a quicker route to the effects described here, without having to duplicate the layer. Choose Fade from the Filter menu (Edit menu in Photoshop 6.0) after applying a filter. You can now change the blending mode of the filter, just as you would if you had created a separate layer.

technical details	
Mamiya RB 6x7 camera	
50mm lens	
Fuji Velvia film	

keyboard shortcuts

Adjust Levels	Control-L/⌘-L
Eraser tool	E
Increase Brush size]
Decrease Brush size	[

keep in mind

Don't forget that you can isolate areas of an image using the selection tools before you apply any special effects. The image at the top of this page has had a blur applied to a feathered circle, giving a vignette effect.

▼ Original shot

04 Two examples: Lighten Mode (left) and Multiply Mode (right).

Third Party Plug-ins

Applications such as Photoshop support a standard for 'add-on' effects filters known as Plug-ins. Some plug-ins are available as freeware or shareware on the web, whilst others cost hundreds of pounds. Plug-ins can only work from within a host application, and are often sold as 'collections', with a variety of filters packaged together. Often aimed at graphic designers, these esoteric packages are rarely worth the investment for the digital photographer. Alien Skin's 'Lightning' filter has been applied to the sky in this image.

Plug-in suites, such as Kai's Power Tools are often powerful mini applications in their own right.

05 Why not go totally abstract: this image has been duplicated three times into new layers. Each layer was then flipped and rotated to create this kaleidoscopic result.

Super-saturated

In general most landscape photographers aim for natural tones in their pictures, with only subtle effects, colors or contrast changes. Some subjects, however, cry out to 'have the color turned up', and it is surprising how effective a 'hyperreal' treatment can be for a wide variety of images.

✎ manipulate it

02 First we'll 'whack up' the contrast using Levels (pages 36–39). Drag the black and white points well in towards the center and move the grey slider to the left. We will completely over-sharpen the image too. I've used an amount of 176% and a radius of 2.5 pixels. This level of Unsharp Masking (Filter>Sharpen>Unsharp Mask) also increases the contrast of the image.

scan it 🖨

01 This 35mm slide was scanned at 1400 dpi for printing at 5x7 inches. The colors, though bold, look a little muted due to the scanning software's attempt at autoexposure.

technical details
Mamiya RB 6x7 camera
250mm lens
Fuji Velvia film

tools
Levels
Unsharp Masking
Hue/Saturation
Add Grain

keep in mind
When performing dramatic changes such as these, always work on a copy of the file rather than the original, just in case it all goes wrong!

03 Now we can boost the colors a little. By using the Hue and Saturation controls (under the Image>Adjust menu). I've only used a +8 saturation increase, but the effect is pronounced.

04 The final touch is to add a little grain to the image. This helps disguise the sharpening artefacts and gives a 'fast film' look to the shot.

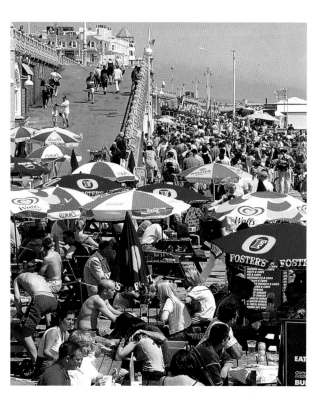

05 An image like this needs to be printed on high gloss, ultra white paper to get the full effect.

TIP BOX

Combine the techniques described on these pages with a tightly cropped semi-abstract composition for stunning colorful results.

technical details
Mamiya RB 6x7 camera
250mm lens
Fuji Velvia film

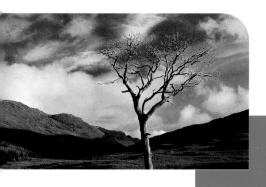

Black and white

The timeless appeal of black and white photography has not been forgotten with the arrival of digital imaging. On the contrary, the ease and fine control offered by the digital darkroom has seen a real resurgence of interest. And the real beauty is you'll never need buy a black and white film again...

scan it

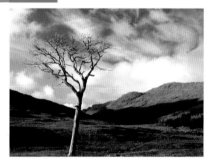 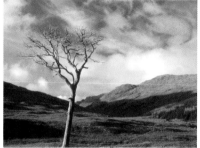

01 Conventional photography demands that you either make the choice between color or monochrome film at the time of shooting, or carry two camera bodies. In the digital darkroom we virtually always start with a color image, be it a digital camera shot or, as here, a scan of a 6x4.5 transparency.

manipulate it

02 Capturing your image in color allows you a finer level of control than using the 'greyscale' modes on your digital camera or scanner. The shot on the left shows the result of simply converting our scan to greyscale mode (Image>Mode> Greyscale).

03 By altering the brightness and contrast we can easily recreate the effect of low (left) and high (right) contrast printing paper.

technical details
Pentax 645 camera
75mm lens
81C warm-up filter
Fuji Velvia film
tripod

tools
Greyscale mode
Brightness/Contrast
Levels
Dodge & Burn tools

navigator
Dodging and burning p54-55
Adding a border p86-90
Levels and Brightness/Contrast p36-40

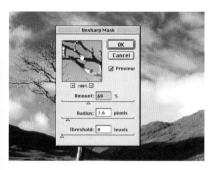

05 Use the Burn tool (the hand) to make areas darker and the Dodge tool (the little black circle on a stick) to make areas lighter. The Burn/Dodge options palette allows you to define how strong the effect is, as well as whether it works on shadows, midtones or highlights. In this example I have darkened the shadows in the sky.

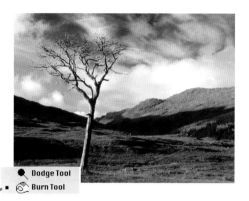

04 Greyscale images can usually bear a little more sharpening than their color counterparts. This is especially true of digital camera shots where over-sharpening of color images can over emphasize noise and JPEG artefacts.

TIP BOX

Using Levels – rather than Brightness and Contrast – controls, gives you even more control over the contrast of your photograph. Try using a very high contrast for a more graphic feel.

print it

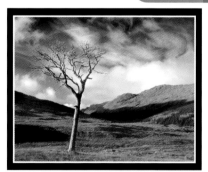

06 Add a black border with a white keyline for a really professional print. Although most photo quality inkjet printers can produce beautiful black and white prints, they do on occasion add a slight color cast. Only experimentation with the printer's settings and with different paper types can iron this out. For more serious work you can buy special monochrome ink sets for certain color inkjet printers.

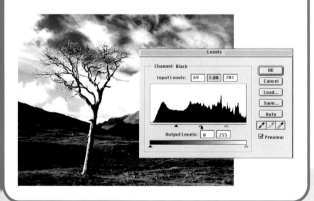

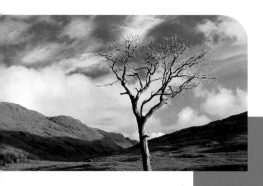

Mixing channels

Although the easiest way to convert a color image to black and white is to switch to greyscale mode, there are advantages to looking at the individual color channels that make up the image. By choosing how much of the red, green and blue information goes into the greyscale mix you can fine tune the process.

 manipulate it

01 Converting to greyscale usually produces perfectly acceptable results. It is worth taking a look at the individual color channels that make up the image to see if any of them make for a more pleasing result on their own. From the Channels Palette menu in Photoshop, choose 'Split Channels'.

03 For landscapes, the red channel inevitably produces the most attractive results. Why? Because this is exactly the same as shooting onto black and white film with a red filter over the lens. Blues, such as skies, are rendered very dark.

02 The application will create three new greyscale images, one each for the red, green and blue channels of the original photograph.

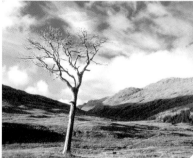

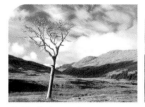
▲ Red channel

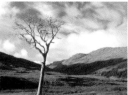
▲ Green channel

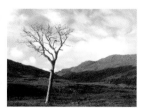
▲ Blue channel

keyboard shortcuts
Zoom	spacebar and control
Rubber stamp	S
Select Image	command L
Select Brush	alt-click/option-click
Wand tool	W

tools
Channel mixer
Split Channels
Unsharp Mask
Dodge & Burn tools

keep in mind
Digital camera pictures often have more noise in the blue channel than any other, so by using the red channel only you can get smoother results.

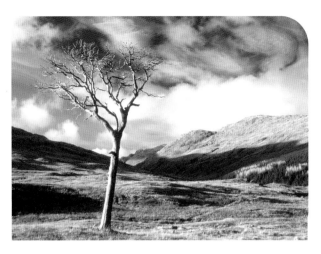

04 Sometimes the red channel on its own is simply too harsh. Fortunately Photoshop offers the ability to create a greyscale image using a mix of the red, green and blue elements of the photograph in whatever proportion you desire. From the Image menu choose Adjust> Channel Mixer.

05 Click on the Monochrome checkbox and experiment using the sliders to alter the amount of each of the R,G and B channels used in the mix. To avoid making an image that is darkened or lightened, ensure the amounts add up to 100% (below). With a little experimentation you can even produce fake infrared shots this way.

06 As I was going for a strong, high contrast effect I chose a mix that was high in red, low in blue and even lower in green. A little judicious dodging and burning later, and I had exactly the result I was after.

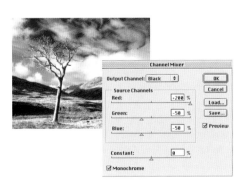

TIP BOX

Black and white images are especially well suited to output on textured papers such as watercolor. You can usually buy 'starter packs' of speciality inkjet papers in photographic shops. These allow you to experiment with different stock types without committing yourself to 25 sheets of a particular type.

navigator
Unsharp Masking p34-35
Dodge & Burn tools p54-55

Adding tone

Adding a tone to a black and white image can transform the mood of a photograph in seconds. The actual process is incredibly simple but the results make it well worth spending some time experimenting with all the subtle variations of warm and cool tones possible.

 scan it

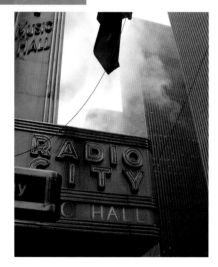

01 Start with any photo: the strong shapes and the vintage style of the sign make this digicam shot ideal.

manipulate it

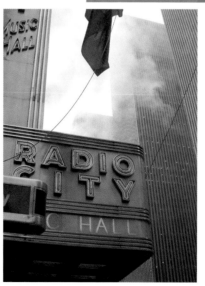

02 Convert to greyscale mode, adjust the contrast and run the Unsharp Mask filter.

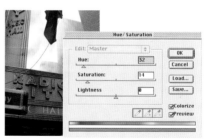

03 Convert the image back to RGB (color) mode and open the Hue, Saturation and Lightness dialog (Image>Adjust> Hue/Saturation). Click on the Colorize checkbox and start to experiment with the sliders. Keep the saturation below about 20 for a subtle tone and don't move the lightness slider.

technical details
Fuji FinePix 6800 Zoom
Digital Camera
Adobe Photoshop 5.0

tools
Hue/Saturation
controls
Change Color mode
Unsharp Mask

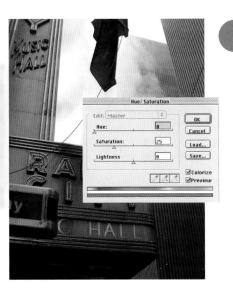

04 Colorwise, browns (or to be more accurate, sepias) and blues are the most popular for toning, but the beauty of the digital darkroom is that you can experiment to your heart's content. Shown here are a few variations I felt particularly suited this image.

05 My final choice was a quite vivid blue. When printing toned images on a color inkjet printer, be prepared for a slight shift in the actual tone as some blues and greens are difficult for the printer to reproduce.

TIP BOX

Use a Hue/Saturation adjustment layer in later full versions of Photoshop to experiment with toning whilst leaving the original pixels untouched.

Using duotone

The technique described on the previous pages can be used in virtually any image editing application as long as it has Hue and Saturation controls. Full versions of Photoshop offer another route to subtle toning that is both fast and highly controllable. So let's have a look at the Duotone mode...

⬛° shoot it

↗ manipulate it

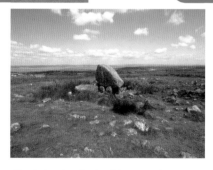

01 Again, start with any color image, preferably one with good contrast and strong shapes. Perform any brightness, contrast and sharpening necessary.

02 Convert to greyscale mode (Image>Mode>Greyscale). When asked if you want to discard any color in the image click on yes.

03 Go back to the Image>Mode menu again and choose Duotone. This mode is actually designed for professional printing using spot colors (as opposed to the more conventional CMYK separations), but it also offers a quick, easy route to attractive toned photographs. From the pop-up menu at the top of the dialog box that appears, choose 'Duotone'.

technical details
Nikon F90
Nikkor 24mm lens
Fuji Velvia Film
Adobe Photoshop 5.5

tools
Duotone mode

keep in mind
If you leave the document in Duotone mode you can only save it in Photoshop (.PSD) format, but you can go back to the Duotone dialog and change the ink used for a different color tone.

print it

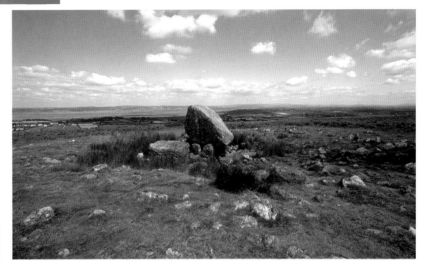

05 Before printing, return to the Image>Mode menu and convert the image back to RGB mode.

04 Click on the white box in the section marked Ink 2 (marked here with a red border). From the Book menu that appears choose Pantone Coated (or, in fact any of the color books on the list) and find a color you like. The lighter the tone chosen for Ink 2, the stronger the toning effect.

Duotone curves Duotones are designed to produce better greyscale images for commercial printing by using two inks, rather than just one (black). Photoshop offers a method of fine-tuning exactly how the black ink and the extra color are 'mixed', using a Duotone curve. You don't need to understand exactly what you are doing to have a play with the curve in order to see how it affects the image by watching it change on-screen. To edit the curve, click on the graph icon next to the color swatch in the Ink 2 section (shown on the top screen here with a red border). You can now click on the curve and add points to change its shape (lower screen).

Graphic effects

Traditional darkroom users have always experimented with special effects on black and white images. The digital photographer has an infinitely more powerful box of tricks at his or her fingertips, many of which are considerably more effective on monochrome than color photographs.

 scan it

manipulate it

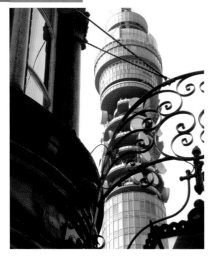

02 After converting to greyscale, we can exaggerate the structural feel of the image by giving the contrast a massive boost. This can be done with the Brightness/Contrast, Levels functions or, as here, with Curves for the ultimate in fine control.

01 We'll start with a telephoto shot of the BT tower in central London. Here shape is much more important than color.

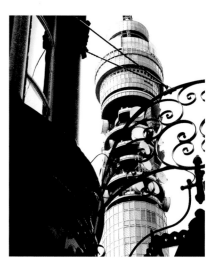

03 The photograph is transformed into a harsh, graphic image that perfectly suits the subject matter.

technical details
Nikon Coolpix 990
Digital Camera
Telephoto
Adobe Photoshop

tools
Change Color mode
Curves
Grain Filter
Add Noise
Hue/Saturation

04 Converting back to RGB mode allows us to add a bold tone to the image. Use the Hue/Saturation controls (with the 'Colorize' option on) and increase the Saturation to around 50 or 60. These settings were used to create the red image on the right.

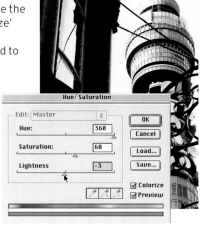

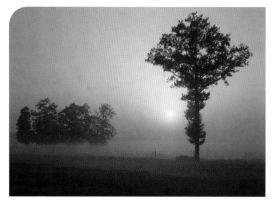

You don't need to restrict this kind of effect to urban scenes; it can also be very effective with simple landscapes. Here, the image is already virtually monochrome and again has the strong shapes which are very sympathetic to the blue toning and grain (this time set to Regular, not Vertical).

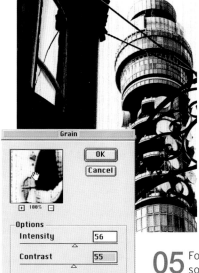

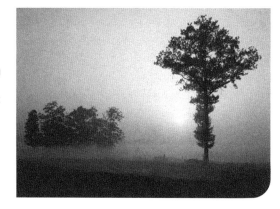

05 For an even stronger graphic effect add some texture with the grain filter. Here I've used the Grain filter (Filter>Texture>Grain) with the type set to Vertical and both Intensity and Contrast set quite high.

keep in mind
The best images for high contrast black and white treatments are those with bold shapes and fine, high contrast detail. Buildings and winter trees work well, general landscapes much less so.

technical details
Wista Field camera 5x4
150mm lens
Fuji Velvia film

Vintage scenes

On the previous pages we looked at turning color photos into ultra modern, stark, graphic images. Some subjects, however, demand a completely different approach: the 'vintage' look. Even if you think the fake antique idea itself should be consigned to history you cannot deny how well it suits some images.

 shoot it

01 Another unremarkable snap, this time of a beautiful building in northern France, grabbed with a cheap digicam. The timeless scene is spoilt somewhat by the clutter of modern life: cars, television aerials and - of course - the ubiquitous daytrippers.

02 The first job is to get rid of the clutter. I cropped the image slightly to get rid of the really messy stuff on the far right, then got to work on the people. With practice the clone tool can work wonders even on fiddly images like this one.

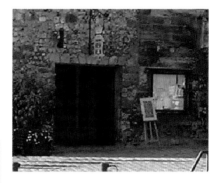

03 Et voilà - tourists removed. Don't worry too much about how well you cover your tracks when cloning away details in this type of project as the following steps will remove some fine detail from the image anyway.

technical details
Olympus C860L
Digital Camera
Wideangle
Adobe Photoshop 5.5

tools
Clone tool
Hue/Saturation
Feather selection
Add Noise filter

further Ideas
Try hand coloring a black and white image: create a new transparent layer and set the mode to overlay (with an opacity of about 40%) and get painting!

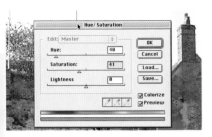

06 The last step is to add some noise (Filter>Noise>Add Noise). Experiment with different amounts but make sure you click on the Monochromatic and Gaussian options.

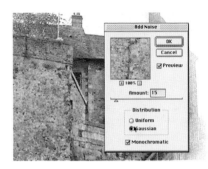

04 Next step is to create a sepia tone. The easiest way to do this in a single step is using the Image> Adjust>Hue/Saturation controls. Make sure you click on the 'Colorize' option. Choose a hue of around 40 for a sepia tone.

07 The obvious choice of paper for printing is a textured stock: try canvas effect or watercolor, both of which are widely available for inkjet printers. With images like this the print resolution is much less important than straight color photos, so you can go pretty large.

print it

05 Create a vignette using the circular marquee. Feather the selection (use a radius of 50 pixels to make a really soft edge) and invert it (Select>Inverse). Press clear (backspace) to remove all the pixels outside your original circular - or to be more accurate, oval - selection.

Glossary

A

Aperture · Variable opening that controls the amount of light that passes through the lens.

Analogue · Continuously variable.

Anti-aliasing · Smoothing the jaggy edges of selection or paint tools in digital imaging applications.

B

Bit · A binary digit, basic digital quantity representing either 1 or 0. The smallest unit of computer information.

Bitmap · [1] An image made up of dots, or pixels. [2] A color mode in Photoshop where every pixel is either black or white (no greys or colors).

Byte · Standard computer file size measurement: contains eight bits. Other common units include Kilobyte (K; 1024 bytes), Megabyte (MB; 1024K) and Gigabyte (GB; 1024 MB).

C

CCD · A Charged Coupled Device (CCD) converts light into electrical current. The digital camera equivalent of film.

CMY, CMYK · (Cyan, Magenta, Yellow). Color printing model used by dye-sub and low-end inkjet printers. CMYK adds black (Key) and is used for most professional printing. Most modern photo printers add pale Cyan and pale Magenta inks for improved pastel tones.

Color Bit Depth · The number of bits used to represent each pixel in an image; the higher the bit depth the more colors appear in the image:

1-bit color = black & white image with no greys or colors; 8-bit color= 256 colors or greys; 24-bit color = 16.7 million colors ('photorealistic' color).

CompactFlash · Type of removable media for digital cameras.

Compression · The 'squashing' of data to reduce file size for storage or to reduce transmission time. Compression can be 'lossy' (such as JPEG) or 'lossless' (such as TIFF LZW). Greater reduction is possible with lossy compression than with lossless schemes.

Cropping tool · A tool found in image editing software which allows you to trim an image.

D

Data · The generic name for any information used by a computer.

Digital Zoom · Camera feature involving enlarging the central part of an image to give a similar effect to a telephoto lens (in fact is simply a crop). This usually results in a drop in image quality.

Dithering · A method for simulating many colors or shades of grey with only a few.

Dpi · (Dots per inch) A measurement of the resolution of a printer or video monitor (see also **ppi**).

Driver · A software utility designed to tell a computer how to operate an external device (i.e. a printer).

E

Exposure · The amount of light falling on the CCD of a Digital Camera or the film in a conventional camera. Exposure is determined by the combination of shutter speed (duration) and aperture (intensity).

Exposure Compensation · The ability to increase or decrease the exposure set by the camera's automatic system.

F

Feathered Edge · Soft edge to a mask or selection. Allows seamless montage effects.

File Format · The way that the information in a file is stored. In digital photography common file formats include JPEG, TIFF and GIF.

Filter · Photo editing software function that alters the appearance of the image being worked on, much like the physical filters that can be put on the front of camera lenses.

Focal Length · The attribute that determines the magnification and field of view of a lens.

Focus · Adjusting a lens so that the subject is recorded as a sharp image.

Flash memory · A type of fast memory chip that remembers all its data even when the power is turned off.

G

GIF · A graphic file format developed for exchange of image files (only supports 256 colors).

Grey Scale · What photographers would call a black and white image, it contains a range of grey tones as well as black and white.

H

Hue/Saturation · An RGB image can also be defined by Hue, Saturation and Brightness, where Hue is the color and Saturation the 'strength'. Hue/ Saturation controls are useful for altering colors without effecting overall brightness or contrast.

I

Image Manipulation · Once a digital image has been transferred into a computer, image manipulation software allows the individual pixels to be altered in many ways. Color corrections, sharpening, photomontage and distortions are all forms of manipulation.

Interpolation · Increasing the number of pixels in an image or filling in missing color information by averaging the values of neighbouring pixels (basically using an educated guess). This 'upsampling' cannot add detail or information but is used by most digital cameras when recording images.

J

Jaggies · The jagged stepped effect often seen in images whose resolutions are so low that individual pixels are visible.

JPEG · A file compression standard that is capable of very high level of compression, but is a 'lossy' method and so can degrade image quality. JPEG allows you to choose the level of compression (and thus the level of quality loss).

L

LCD monitor · A small color screen found on many digital cameras that allows previewing/ reviewing of images as they are taken.

M

Mask · In digital imaging an 8-bit overlay which isolates areas of an image prior to processing. A mask is used to define an area of an image to which an effect will be applied. Often called a selection.

Megapixel · One million pixels; a measure of camera resolution.

Marquee · Outline of dots created by image editing program to show area selected for manipulation, masking or cropping.

Magic Wand · A selection tool that automatically selects areas of continuous color around the point where it is clicked. The tolerance setting defines how near a color must be to be included in the selection.

N

Noise · Unwanted electrical interference that degrades analogue electrical equipment. In digital cameras this most often occurs in very low lighting or shadow areas in the form of pixels of the wrong color appearing at random in dark areas.

O

Optical Resolution · In scanners the maximum resolution possible without resort to interpolation. Also used to describe a digital camera's true CCD resolution.

P

Photosite · A single photosensitive element in a CCD which translates to one pixel in the resultant image. Also known as a CCD Element.

Photoshop Plug in · A small piece of software that adds extra features or functions to Adobe Photoshop or other compatible applications.

Pixel · (PICture ELement) The smallest element of a digitized image. Also, one of the tiny points of light that make up a picture on a computer screen.

Ppi · Pixels/points per inch. A measure of the resolution of scanners, digital images and printers.

R

Removable Media · Small memory chips which store the captured images.

Resample · To change the number of pixels in an image. Upsampling uses interpolation to increase the number of pixels. Downsampling throws away pixels to reduce the size.

Resize · Changing the resolution or physical size of an image without changing the number of pixels. For example a 2x2-inch image at 300dpi becomes a 4x4-inch image at 150dpi. Often confused with Resampling.

Resolution · Measure of the amount of information in an image expressed in terms of the number of pixels per unit length (i.e. pixels per millimeter or pixels per inch). Camera resolution is usually defined as the actual number of pixels in image (i.e. 640x480) - see **dpi** & **ppi.**

RGB · Red, Green and Blue. TVs, monitors and digital cameras use a mix of R,G & B to represent all the colors in an image.

S

Saturation · The amount of grey in a color. More grey means lower saturation. See also **Hue/Saturation**.

Selection · An area of an image isolated before applying an effect.

T

Telephoto lens · Lens that has the effect of making subjects seem closer than they actually are.

Thumbnail · A small, low-resolution version of a larger image file that is used for quick identification and for displaying many images on a single screen.

TIFF · The standard file format for high-resolution bitmapped graphics.

UVW

Unsharp Masking · A software feature that selectively sharpens a digital image in areas of high contrast whilst having little effect on areas of solid color. The effect is to increase the apparent detail and sharpness.

XYZ

White Balance · In digital camera terms, an adjustment to ensure that colors are captured accurately (without any 'color cast') whatever the lighting used. This can be set automatically, using presets for different lighting types or measured manually.

Wideangle lens · A lens of short focal length giving a wide angle view, allowing more of a scene to be fitted into a photograph.

Zoom Lens · Variable focal length lens that allows the user to adjust his field of view ('zoom in or out').

Acknowledgments

I would like to thank the photographers - Peter Adams (www.padamsphoto.co.uk), Peter Cope, Bill Coster (www.billcoster.com), Terry Hall (allankelly@ntlworld.com), Maggie Sale (maggiesale@home.com), David Sellman - whose work appears throughout this book, as well as the staff at Rotovision, without whom it would have been an infinitely more difficult job.

I would also like to thank the many people working for manufacturers of digital imaging products who kindly loaned equipment for the production of this book, especially the staff at Fuji Photo Film (UK) Ltd. Many of the photographs in this book were taken on Fujifilm FinePix cameras and the results output using Fujifilm's superb Frontier Digital Minilab.

A special thanks must also go to Jeremy Cope at Adobe for providing Photoshop 5.5 and 6.0, used for the projects in this book. Finally, I must thank my ever-patient wife Claire for her continuing support in everything I do.

Simon Joinson